T0386629

The Art *of* Discovery

ROBIN BRONK
JEFF VESPA
NANCY ROUEMY

The Art
of
Discovery

Hollywood Stars Reveal
Their Inspirations

RIZZOLI
NEW YORK

New York · Paris · London · Milan

I hail from Clemson, South Carolina. My dad was a professor at Clemson University and we settled in the bosom of the South. My hometown is right out of a Pat Conroy novel. We had Judge Keller's General Store (where Judge kept everyone's accounts in a handwritten ledger, and knew everyone's size in denim overalls), and my schoolmates were named Rhett, Scarlett, and Melanie. Clemson had a couple of traffic lights and two movie theaters (that's pronounced *theee-ay-toors*). D. W. Daniel High School football games were every Friday night. On Saturday nights, we'd cruise up and down Main Street. Sunday dinners were at the Clemson House Hotel and, come spring, if ya'll behaved yourself, the prom was in the high school gym (complete with a paper-mâché Eiffel Tower). Life was not just good, it was downright delightful.

At D. W. Daniel High School, I happily was taken under the wing by someone quite special, Mrs. Frye, the chorus teacher. Mrs. Frye was truly a pioneer among educators. Before it was *Glee*-fashionable, she tackled football players into chorus, got the cheerleaders to paint scenery, and convinced the hippies to put aside their macrame and learn to shuffle/step/slide across a stage. Mrs. Frye was a master at using the arts to help us discover what the curriculum was really all about. History and literature came alive with the Dixie Darling version of *The Importance of Being Earnest* (and if you haven't seen a production of a Southern-fried *Fiddler on the Roof*, then y'all are just missing out). We discovered what math, science, and technology meant by building sets, designing lighting grids, and wiring sound boards. Mrs. Frye taught us that in order to live life, one must experience art.

This book, *The Art of Discovery*, is the cornerstone of The Creative Coalition's campaign to encourage support for arts in public schools and arts in communities.

As The Creative Coalition pushes for a more significant public investment in America's arts organizations and arts education programs, policymakers seem to have an increasingly insatiable desire for data. What's the return on investment? How many jobs will it create? How much tax revenue will the arts generate?

These are legitimate questions, and the answers are compelling. The federal government found that arts and cultural industries contribute $504 billion annually to our gross domestic product, and employ more than two million Americans.

We also know that young people's involvement in the arts has a huge impact on them later in life. They do better on standardized tests, are more likely to graduate from high school, and increase their chances of graduating from college. Data conclusively establishes links between the arts and achievement in science, technology, engineering, and math.

A child's love of drawing, playing instruments, acting in the school play, or dancing is important not just because it will boost our economic output, but because we see the joy that art brings. Humans have an innate need to create and tell stories, and that content enriches our lives and gives us a narrative framework for our own experiences. A few bars of music can evoke even the dimmest of memories, while architecture and design define the spaces we live in.

At its best, art helps us discover who we are. What could be more important than that? I hope you savor the stories in this book, and are inspired to remember and cherish the moment when you discovered the richness that the arts brought into your life.

Thank you to the extraordinary members of The Creative Coalition, who gave their time to this book, and who trusted me and our team with their most personal and poignant moments. You are a very special fraternity of the most accomplished artists, and I am privileged to be a part of it. Thank you to Michael Frankfurt and Tim Daly, and Renaissance Hotels for allowing me the opportunity to work on a project so personally rewarding. My deepest gratitude and appreciation to my partners in creating this book, Nancy Rouemy, Jeff Vespa, Robb Pearlman, Daniel Melamud, and Catherine Leitner. And to the most inspirational artists in my life—Eliza, Danielle, and Kiki.

—ROBIN L. BRONK
CEO, THE CREATIVE COALITION

INTRODUCTION

I started taking portraits when I was 15 years old. It was the summer before I left for boarding school and, at the time, I was entrenched in Baltimore's punk rock scene. Misfit and outcast kids from all walks of life became my surrogate family. We would all meet up to see bands at The Loft, a club downtown. This was such an amazing moment in time, and even at my young age, I realized it was unique and special and something that most people would never get a chance to experience. In many ways, it felt like the end of my adolescence. I was afraid this time would be gone too soon, and thought, "I have to capture this moment." So I picked up my mom's Canon AE-1 camera and read the manual. And that is how I became a photographer.

When I moved to Los Angeles, I wanted to re-create that same bohemian sense of community I'd experienced in Baltimore. After all, actors are artists and, to my mind, that's the same thing as being a punk rocker. Actors are a little strange and quirky, and since they always feel like they're on the outside looking in, they're more comfortable surrounding themselves with like-minded people. These artists happened to be the kind of creative people that I wanted to befriend. So over the next 15 to 20 years, as I photographed them again and again at film festivals, award shows, and charity galas all over the world, I built a lot of relationships with them. This book is, in part, a testament to those relationships.

The majority of the photo shoots featured in *The Art of Discovery* were done in my own home, which has evolved into a modern-day salon of sorts.

I never ask my celebrity friends for favors, but when I reached out to them for this project, they all came through for me. It was incredible — overwhelming — to feel all of their love and support. We came together to create a magical moment, a pure artistic collaboration, but essentially, we were just playing. Our goal was to create a piece of art, but honestly, the experience of making the book was so fulfilling that I realized the end product was not nearly as important. It is not about the destination for me; it's the journey that matters. Ultimately, I cannot find words to express how much my friends mean to me, so I photograph them instead. That, in essence, has been my own personal discovery.

I am deeply grateful to Robin Bronk, Nancy Rouemy, and Mike Windle, who worked tirelessly to bring this book to fruition; also Robb Pearlman and Daniel Melamud from Rizzoli for guiding me and making this project possible. I would also like to thank my mother Marlene and father Julien, who have always believed in me, as well as my wife, Emily, who was by my side every step of the way.

— JEFF VESPA

I first learned to see — really see — in the same room where Andy Warhol studied art. I was there over 30 years later, at ten years old, but Warhol and I had the same mentor: Mr. Joseph Fitzpatrick. In the Tam O'Shanters art class, held in the Music Hall at the Carnegie Museum in Pittsburgh, Mr. Fitzpatrick would pace the stage, bellowing what I came to regard as my mantra, "Look, to see, to remember, to enjoy."

At the start of each of Fitzpatrick's classes, we created a "Notes and Sketches" page, beginning with pencilling horizontal holding lines, and then letters, and numbers. As the weeks progressed, I started focusing on letterforms. "Art," he taught us, "is not just a subject. It's a way of life. It's the only subject you use from the time you open your eyes in the morning until you close them at night. Everything you look at has art or the lack of art."

Everything *I* look at, I look at for type. If I'm browsing in a shop and find imported soaps and perfumes, I will stop in my tracks. If I'm at a dinner party, I'll zero in on the wine label. If I'm looking for an address on the street, I'll get pleasantly distracted by the variety of house numerals. When I cut off a hang tag from a new purchase, I'll critique it before I throw it away. If someone offers me a mint, I'll pass for the tin lid. The embroidered initials on a man's dress shirt, the engraving on an old spoon or tombstone, the graffiti on a building, the designs on foreign currency, the lettering on a baseball bat, the script icing on a birthday cake. I never stop looking.

The Art of Discovery has given me a prized opportunity to create a book that showcases art, discovery, and typography while promoting the invaluable efforts of The Creative Coalition. Being published by Rizzoli is a dream come true; it's been a joy working with Robb Pearlman, Daniel Melamud, and Robin Bronk. I am very grateful to Jeff Vespa for giving me the freedom to collaborate and art direct many of the artists at the Sundance Film Festival in Utah and, via the Internet from New York, in Los Angeles. To all of you on set who knew me only by my voice, yet gave me your faith and trust, I thank you.

—NANCY ROUEMY
PRINCIPAL, WE LIVE TYPE LTD

A NOTE ON FONTS

I selected stencil fonts for *The Art of Discovery*'s display text, not only because their usage has moved beyond the industrial application or Le Corbusier's architectural stamp, but because they have become the modern didot of luxury. The spaces between the lines and forms in the characters allow the eye to experience "entry points," to meander in and around the words themselves, allowing readers to make their own discoveries.

The principal typefaces used in the composition of *The Art of Discovery* are stencil fonts Sensaway Pro, Bery Script, Bery Tuscan, Sevigne St, Vanitas Stencil, Ogaki Std, and Diversa; and text fonts Trivia Serif Family, and Trivia Sans Family.

ϕⅠ$

SCOVERY

RENAISSANCE®
HOTELS

We live in a world in which we're all rushed and seeking inspiration. Everyday life is full of challenges and information overload, and the concept of time has become a most precious gift. *The Art of Discovery* beautifully captures that singular moment in time that serves as our own personal muse. It is often in these unexpected moments when we feel most inspired to think differently. It can happen anywhere, at any time.

I am inspired by The Creative Coalition's tireless efforts to encourage these extraordinary moments of discovery through the creative arts. If we look back and reflect on certain moments in our own life, we are likely to find that the arts have often played a unique role in inspiring us to build, create, explore, and grow. The Creative Coalition has arranged an extraordinary collection of deeply personal stories that connects to the vision of Renaissance Hotels, which encourages today's modern traveler to ignite their own curiosity through music, film, art, photography, and literature while on the road.

We hope that the artists showcased in *The Art of Discovery* will inspire your own moment of discovery.

—TINA EDMUNDSON
GLOBAL OFFICER, LUXURY & LIFESTYLE BRANDS

are we

RECRDING

?

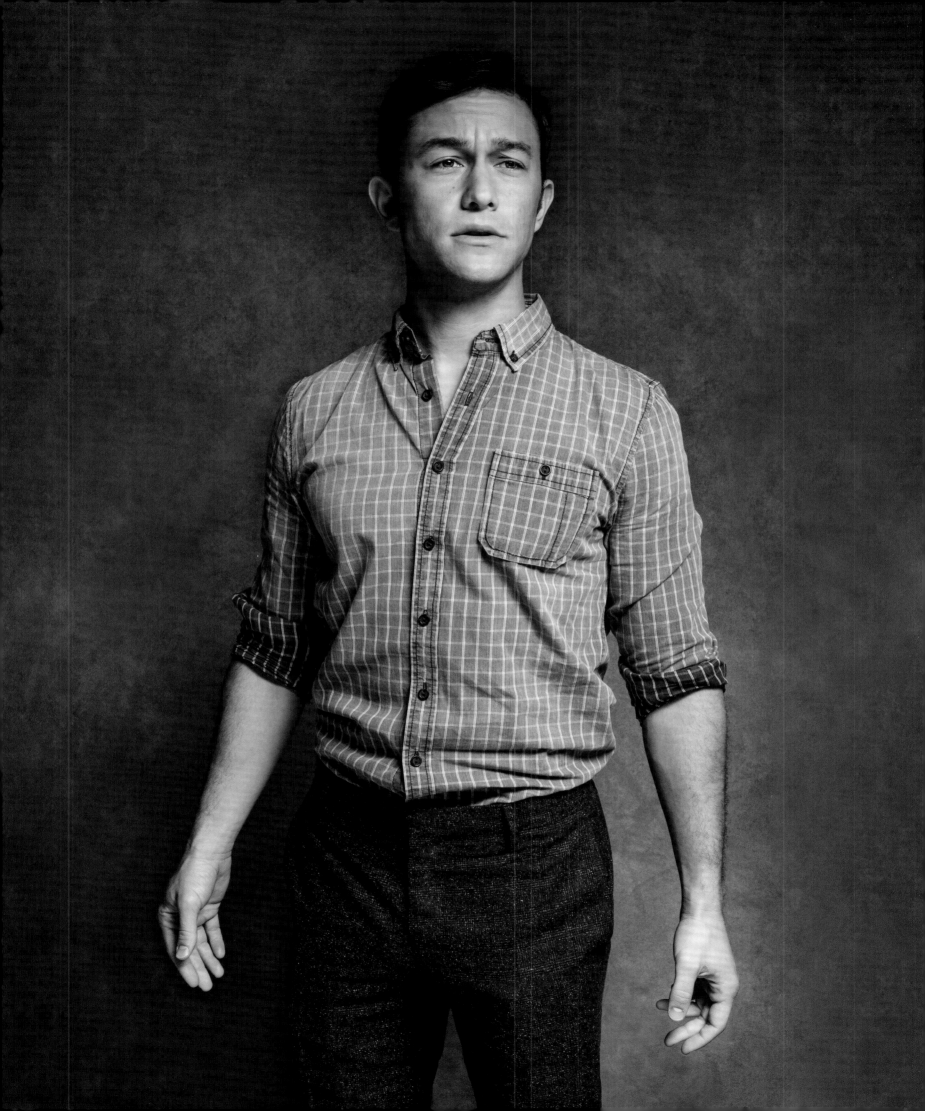

My time with Stanley Kubrick
on *Eyes Wide Shut* was like being in
film school, philosophy school,
and life school all at once. He was a
great teacher, wise and funny—
an open book. It was two years
of questions, exploration, and time
talking in his office.

**Stanley taught me to go deeper,
to ask life's most important questions,
and to think critically.**

He propelled me into the deepest
part of my life and career.

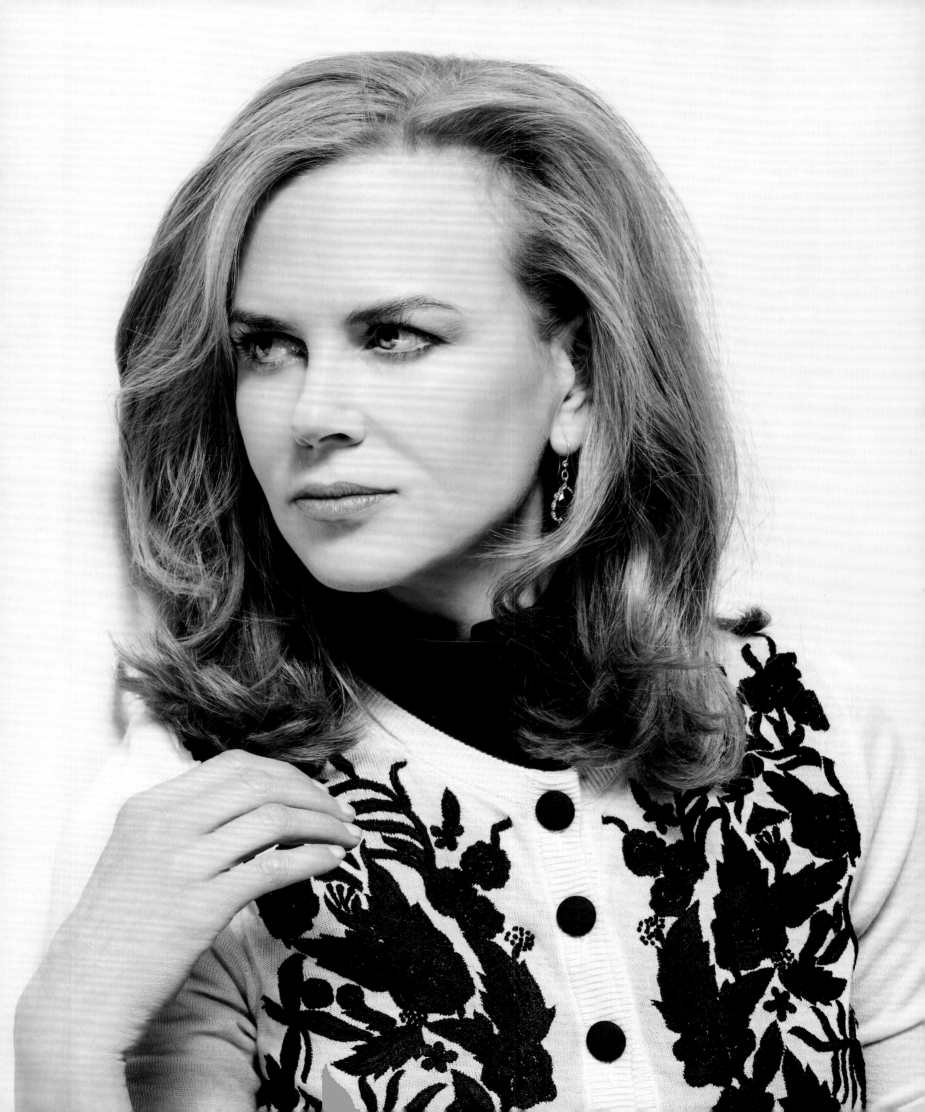

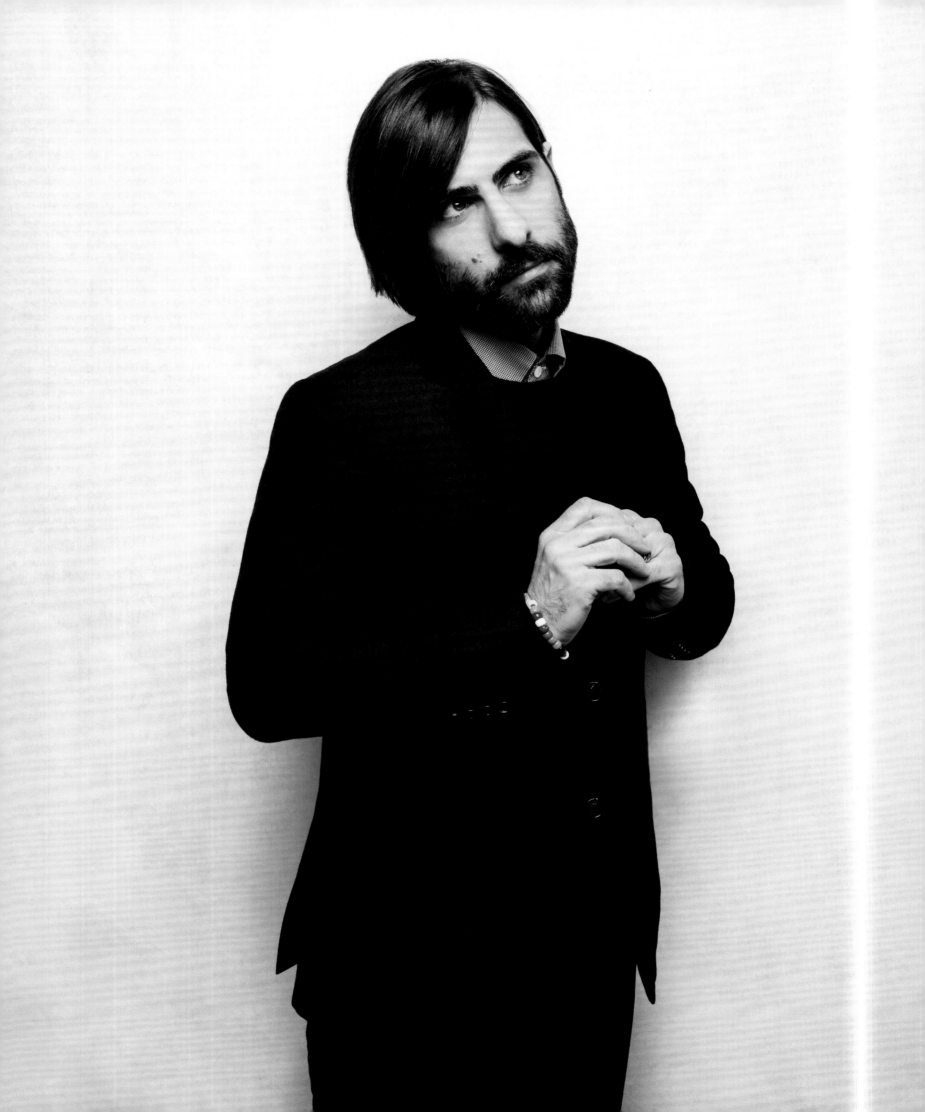

I LISTENED TO LOTS OF

Beatles

records when I was younger.
I was intrigued by

JOHN
LENNON

His voice sounded different on different songs.
Sometimes highly affected, sometimes higher pitched,
sometimes very slow and droopy. He was
able to change his identity by changing his voice.
In "Strawberry Fields," his voice in
the first verse is higher pitched than it is
in the second verse, yet all very
beautiful sounding. It makes
me feel like

I can do anything

Older actors have always inspired me.

I equate it to how the ancient Romans would respect their elders. I worked with Dianne Wiest on an obscure Ostrovsky play, *The Forest*. Dianne was relentless. Once, I was on my way back to the rehearsal room from lunch, and I passed a pizza place. I saw Dianne sitting in the back with her head in her hands, looking completely depleted. It seemed like she was so tortured from trying to make this play work. There was a woman who I've watched for years in movies, and think is a brilliant actor, still asking herself the same questions that she's asked herself since her first movie. She helped me discover that it's more about the journey and the process and not about the end result; because an actor's journey never ends.

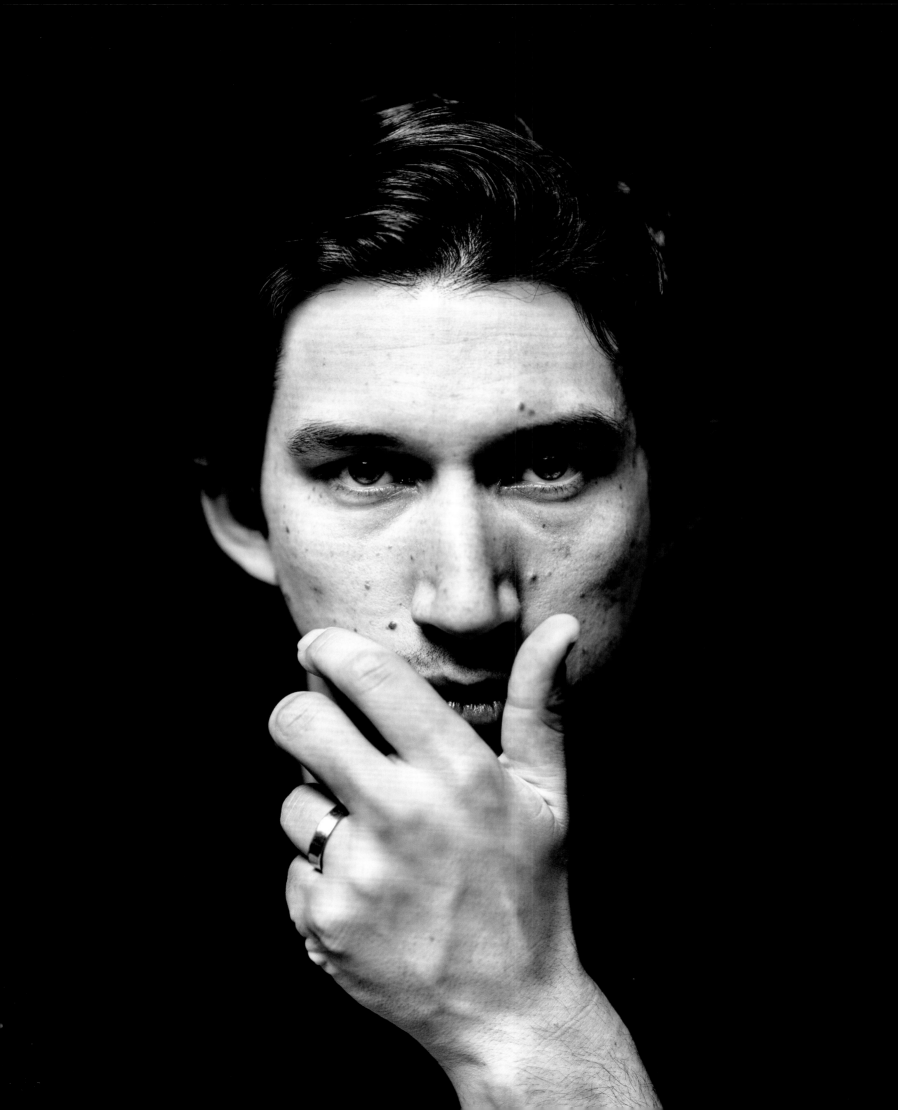

5

RHYTHMS.

That's a type of dance that broke down all of my walls
and allowed myself to experience my sensual body for the first time.
I was able to drop a lot of insecurities and false self-accusations
that didn't need to exist internally. Dancing opened me up
to the possibilities of just existing as a human being, versus being
in my head and criticizing every single moment.

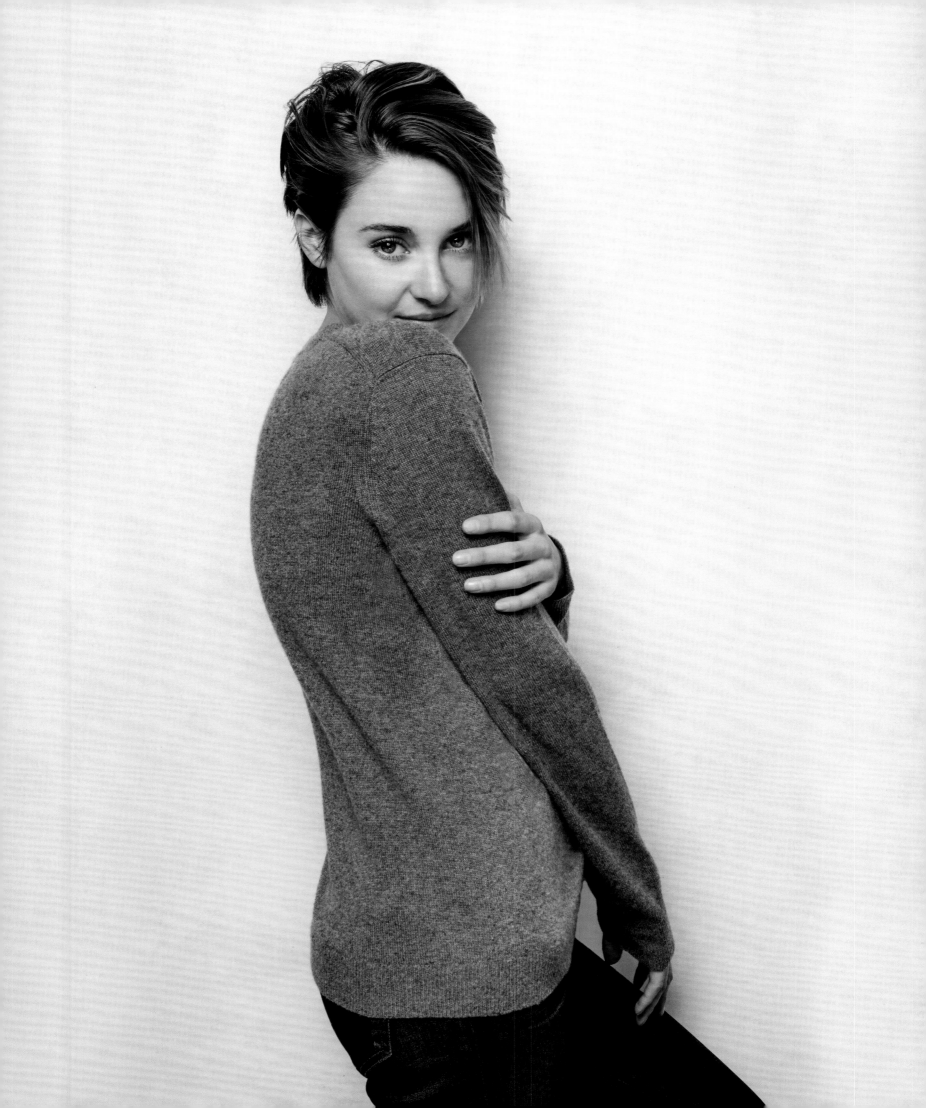

IT WAS THE DECISION
OF A LIFETIME. I HAD A
COUPLE HUNDRED BUCKS,
A BACKPACK, AND NOT
MUCH ELSE, OTHER THAN
A TON OF WILL.
I CERTAINLY WOULDN'T BE
HERE TODAY IF I DIDN'T
MAKE THE DECISION
TO GRAB THAT BACKPACK
AND WORK MY WAY
TO CALIFORNIA.

JARED LETO

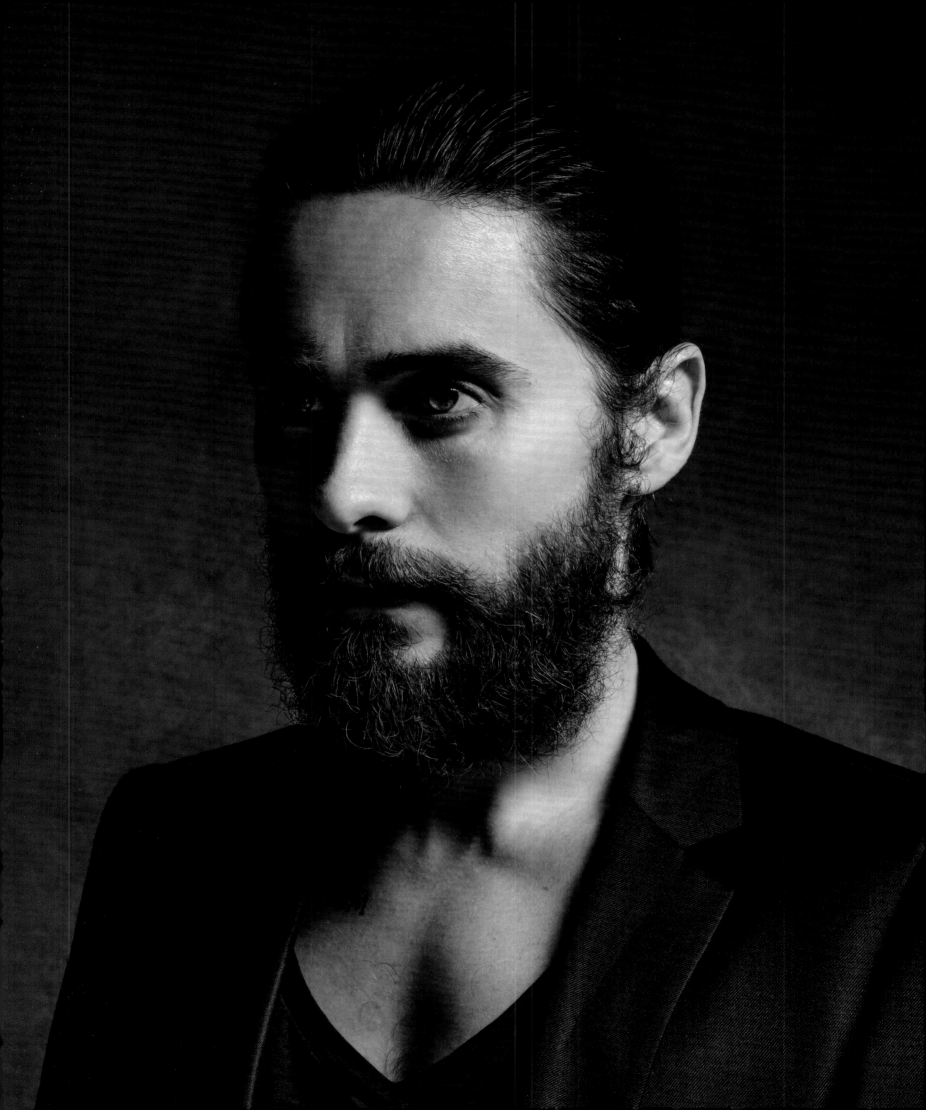

I grew up in the Cayman Islands.

I was outside all the time, running, swimming, fishing. But I was stuck on a small island in the middle of the ocean and, at certain points, the shores did start to feel like they were closing in on me. One escape was movies. We had one theater on the island with two screens, and we'd get movies about a month and a half after they had come out in the States. I was watching *Home Alone*, and it was glorious. It was the most magical movie I had ever seen. I was a kid. I could relate. I went to sleep that night and had a dream that I was the kid in the *Home Alone* house with a BB gun, a blowtorch, and the ornaments. When I woke up, it felt like a communication in a weird way. I understood that's acting, and I loved that I wanted to be an actor. I'm going to make those movie things. I had no idea how to do it, what to even call making a movie, but I wanted to do it. I loved and still love a movie's ability to take me on a journey. It didn't matter that I was on an island, that the temperature was 100 degrees, and it was 1,000 percent humidity. I was in a cold movie theater, and I was right where that director wanted me to be. That's a mystical power. Movies, not to sound ridiculous, can help get people out of their own situations for long enough to have an epiphany.

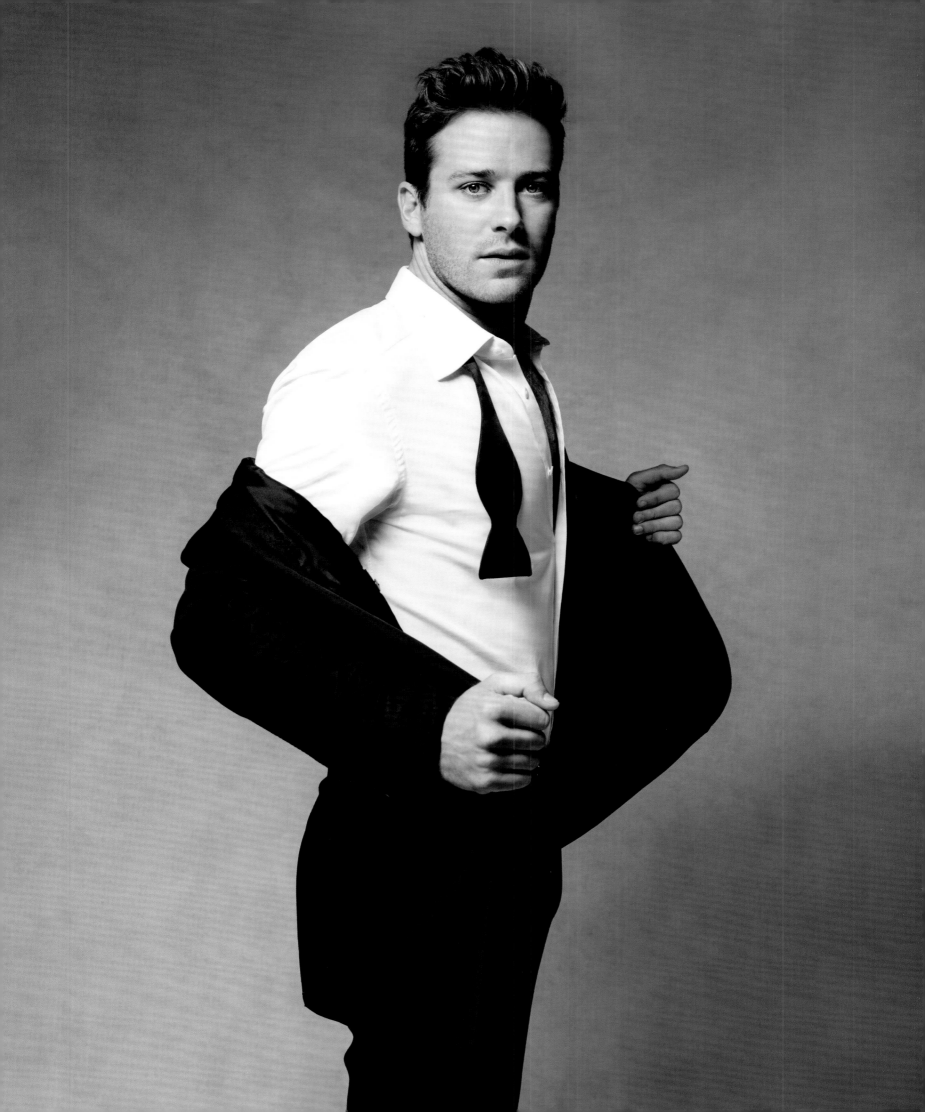

Seeing Cherry Jones
in the play,

THE
HEIRESS,

in Los Angeles when I was 13
was my first example of watching
a real actress on stage in a
real dramatic play. The way she
commanded the stage, her dress,
her hair, her devastatingly
beautiful performance—I realized
that's what I wanted to do.

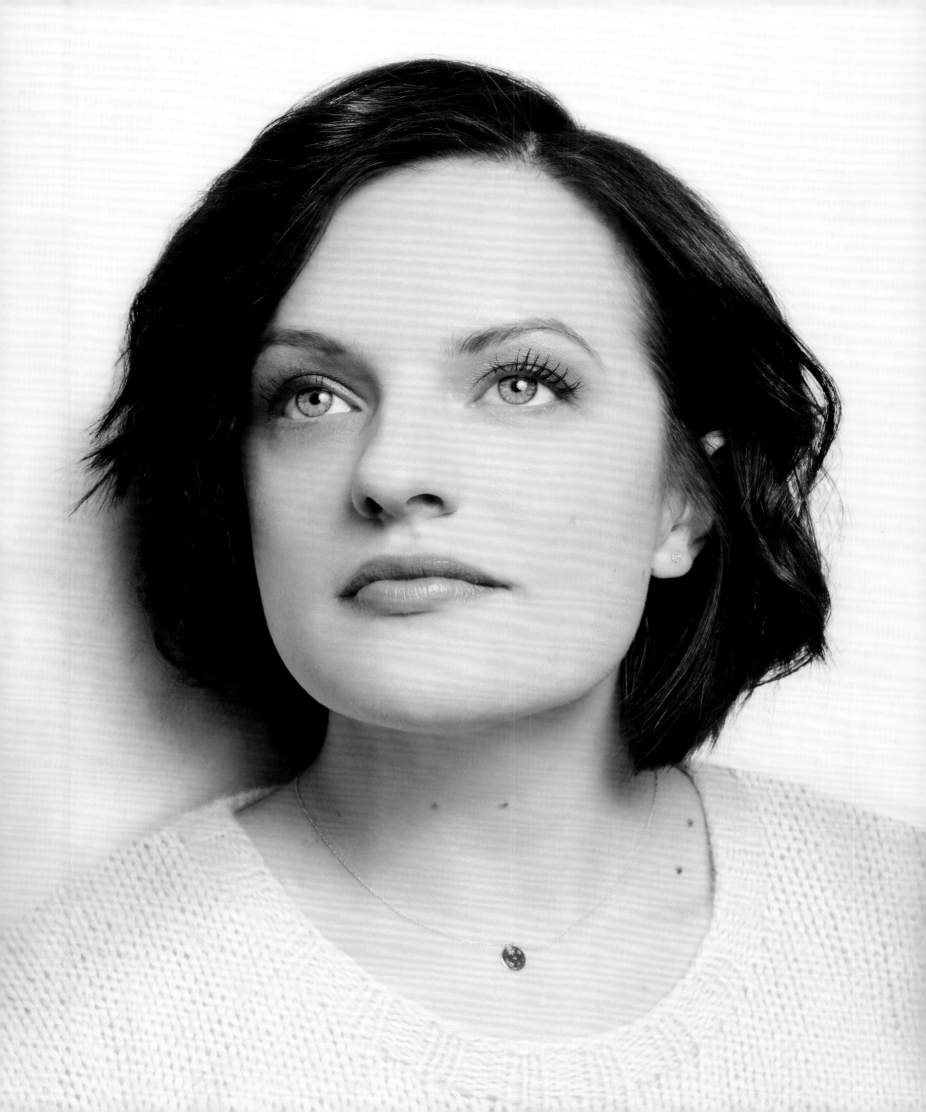

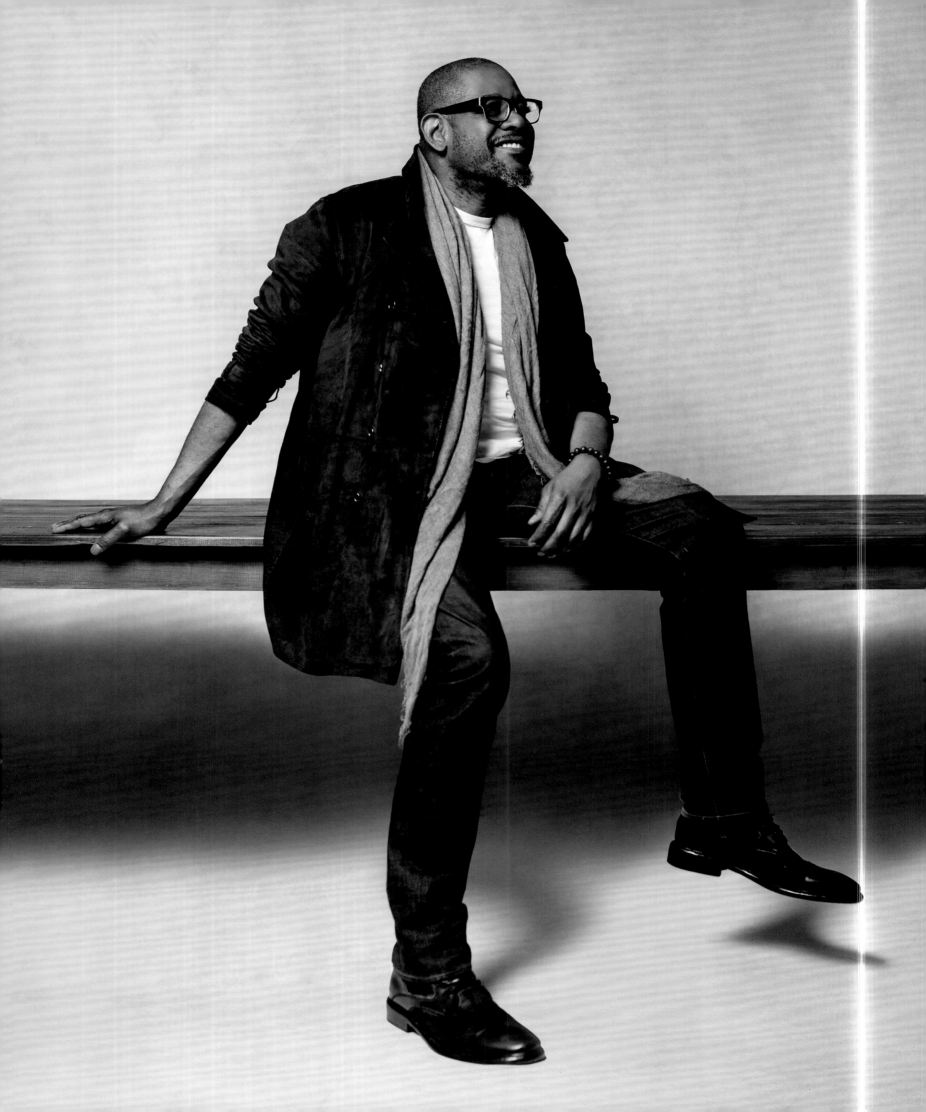

I WAS IN UGANDA AT AN ORPHANAGE IN MASINDI watching a soccer match with young kids who all had served as child soldiers. Next to me sat a Danish gentleman who was very sad. I asked him why he was so sad and he told me that he had started a program rescuing child soldiers and re-uniting them with their families. He had just com-pleted his first reunion for a boy with his mother and his sister. That same night the boy killed his sister, and the man shut down the program. I was so sad for this man who had such great intentions.

It inspired me to be really careful, really vigilant, about making judgments.

It could have been a totally different outcome with another boy. Our first assumption is "he killed his sister." We just don't know what happened, or why it happened. All we know is that this boy suffered another trauma that has to be looked at holisti-cally, from every angle.

This man's story changed my life. I learned that I can never completely know. The small things people do on a daily basis—getting up, getting dressed, walking out the door, facing the demons inside of themselves. Small, seemingly ordinary little acts can be heroic. And so wherever I go, I try to listen very carefully to people and really see who they are and experience what they've experienced. Then I can hopefully, in partnership with them, help to encourage the best decisions.

September 6, 1992. It was a swampy, humid night
in West Philadelphia. I was wearing cut off
jean shorts, a floral boat neck cotton top, and a
Boston Red Sox baseball cap to contain the
frizz in my very curly hair. I met a cocky 19-year-old
from a faraway place called Oregon. It was the
moment that impacted every moment after,
that's had the most profound effect on my happiness
and well-being, my security, and confidence.
It is the moment that brought me my children,
who make everything matter.

LOVE
IS PROFOUND
and I found it that night.

ELIZABETH BANKS

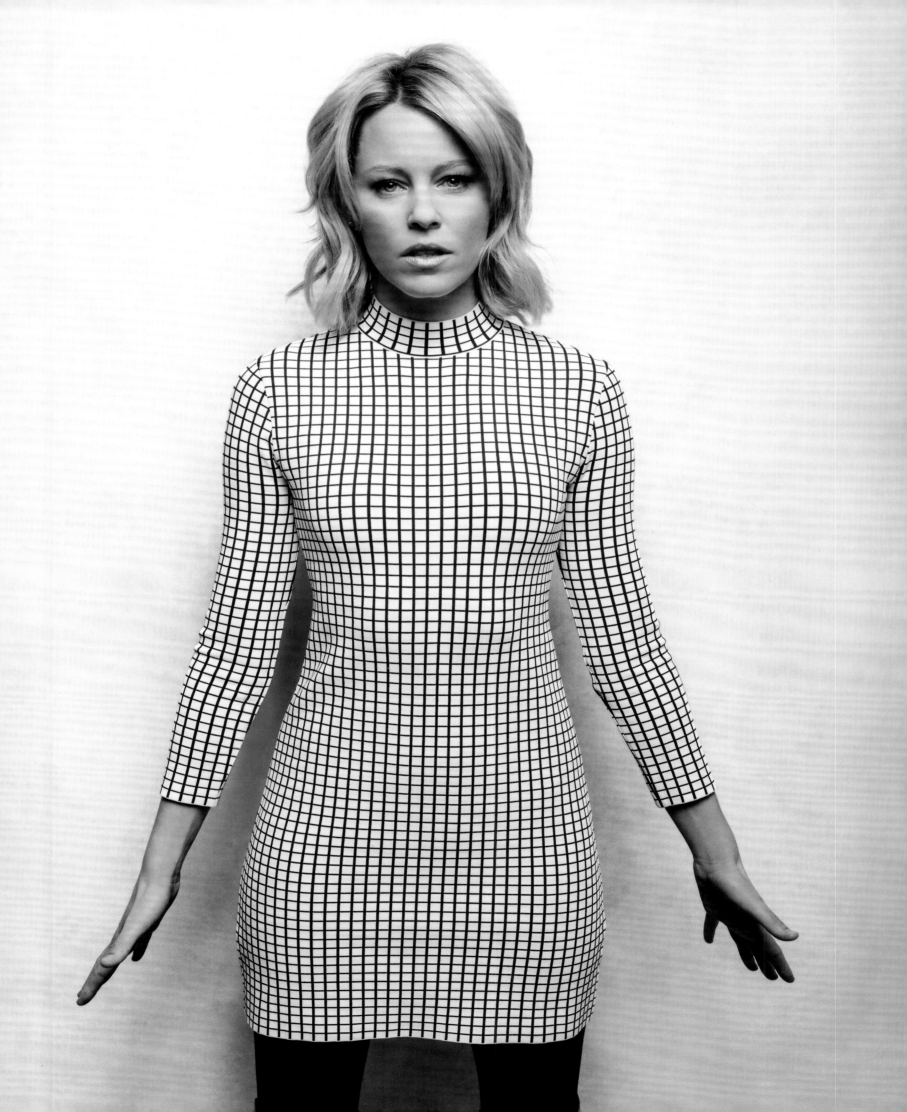

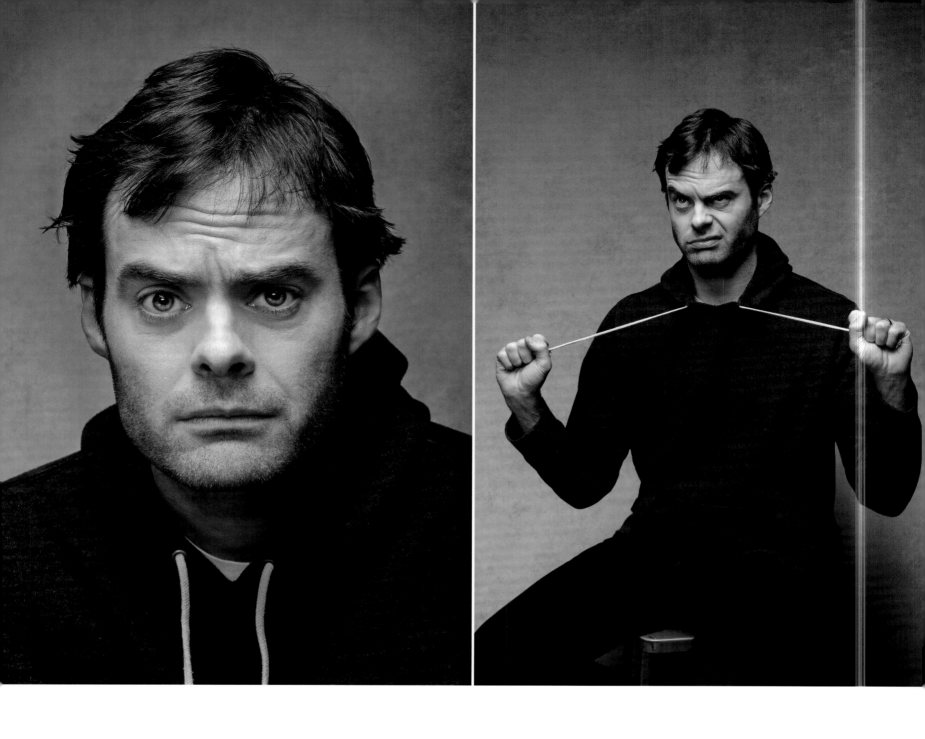

\mathcal{I} had been living in Los Angeles for four years. I moved there to make films, but instead I found myself slaving away as a post-production assistant on a talk show about women's health. One night, a fellow production assistant asked me if I'd like to see his Second City Level 5 show. I said sure, and thought *Level 5? Does that mean it was on top of the theater?*

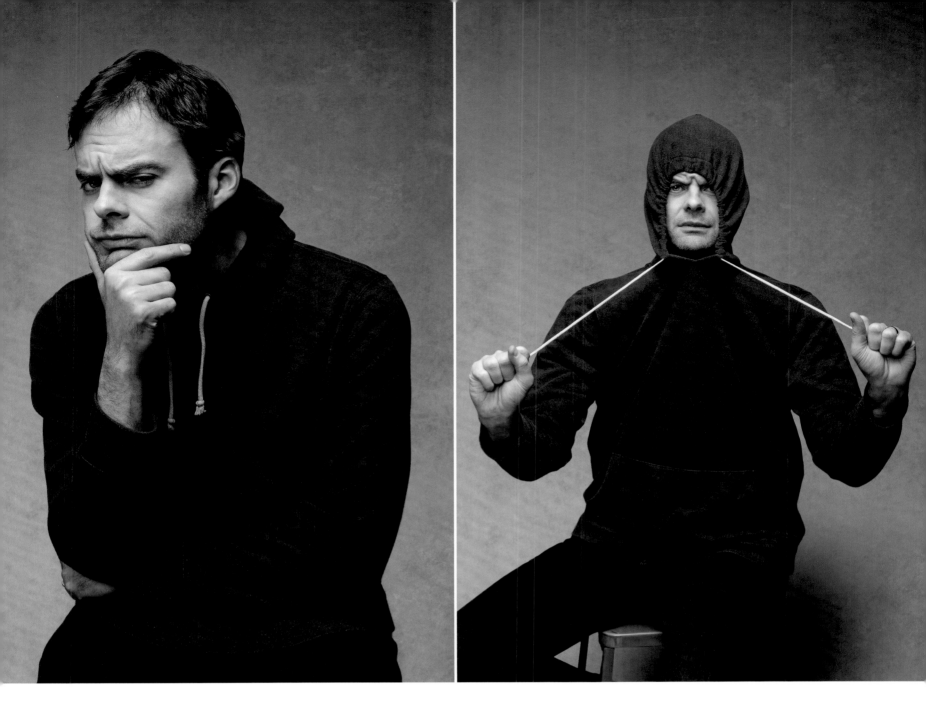

I later found out that Level 5 was the highest level at the Second City
Conservatory. This was a class show. I wanted in! I'd moved to LA
to be creative and wasn't doing it because I needed to pay the bills.
Once a week I went to my Second City class, got up on stage, and failed.
And that's the best thing in the world for any performer.

BILL HADER

The moment I realized that the **bullies are scared, too.**

TILDA SWINTON

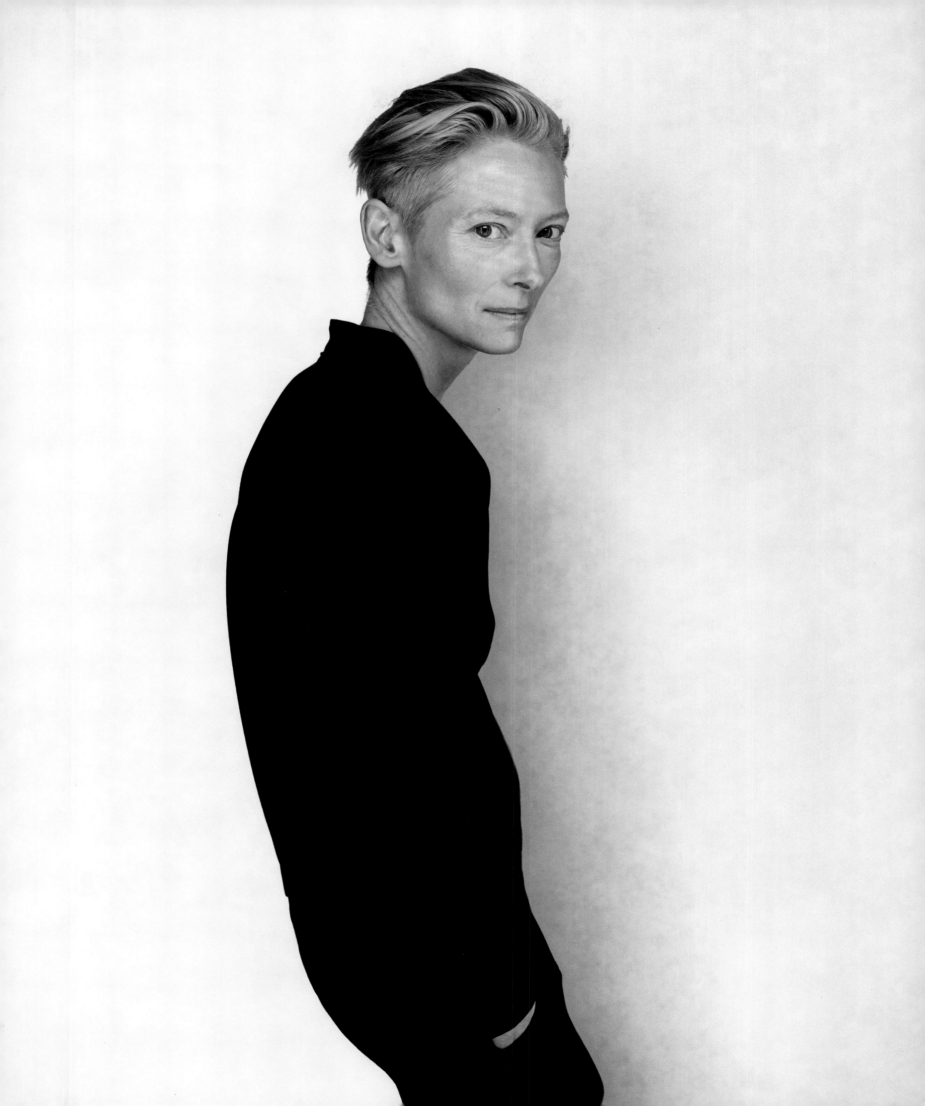

I deejayed for about ten years for fun. I did it with iPods and CDs for a long time. I used to carry cases filled with CDs. I did it because I just liked to do it. I started when I was 19 in New Zealand as an act of self-expression. Then there was a moment when I realized that professional deejays were taking what I was doing seriously. They told me,

"YOU CAN DO THIS."

That kind of changed everything for me. It made me pay more attention to what I was doing. I think until someone says to you, "You're good at that," you don't realize that you can— you're just doing something because it fulfills you. If you don't take what you're doing seriously, nobody else will. And that's fine. But once they do, it changes things.

My entire childhood, I wanted to be a magician.

I grew up watching the greats of the day on television — Mark Wilson, Doug Henning, and Blackstone. I wanted so much to join their geeky ranks. I was the kid who was in his room every day trying to discern from books and photographs, how to palm cards, vanish coins, restore cut ropes. It was all I wanted. The trouble with magic back then was that I never thought of creating, I only thought of copying. That is really what an apprentice magician does. They copy the work of those who came before, mastering the skills until one day, if they have the goods, they can create their own illusions and personas. I was a very unimaginative kid, alone in my room, copying moves created decades before. I never thought of magic as anything other than that. I never even really thought of it as performing. When I was 12, I had developed a fair set of skills but was just good enough to know that I was not really good enough. My hands were genetically small and especially challenged to accomplish the particular dexterity of the great close-up magicians. I realized that my dreams of doing magic in some bigger sense were less and less likely. That was also when I moved from one town to another. Amazingly, as I was hanging out, the new stranger in school, the theater kids asked me to join a production they were doing. Happy to have some friends, I agreed. These kids were total theater devotees. Every weekend, we would bus into New York to see shows. It was much cheaper then. *Pippin* was a revelation. It was a complete synthesis of theater, pop music, storytelling, dance, and magic. The piece was full of magic personified in the glorious performance of Ben Vereen. I was transformed the minute the curtain went up on the wall of smoke and disembodied hands poked through the mist, slowly morphing into full bodies. I was agog.

Vereen was a revelation — powerful, dynamic, charismatic, funny, amazing. In that instant, I realized that the theater is an illusion, a huge and amazing illusion. And, even though I was not likely to become a masterful illusionist, the illusion of the theater was well within my grasp. That moment showed me the limitless potential for everything I already loved. I would still have magic in my life. It would simply be a different kind of magic. That is what creative inspiration is about. It takes what you have and jolts you into reimagining more possibilities than you ever had before. That has been done for me by shows, songs, art, and most especially by the work and life of other people. It is why I try, whenever I can, to offer something like it to others. It all began with the words, "We've got magic to do just for you. We've got miracle plays to play. We've got parts to perform, hearts to warm. Kings and things to take by storm, as we go along our way."

Worked two jobs and did community theater when I was five. I had only seen my mom in work clothes or sweats. She was always a little disheveled and dirty, just like a mom. She never dressed up or put a lot of effort into how she looked. When I was finally old enough, she took me to rehearsal with her, where I'd just hang out underneath the piano and color. One day I was bored with coloring, and looked up to see my mom was on stage, playing Rosie in *Bye Bye Birdie*. She looked enchanting—long hair, make-up, and a beautiful red dress. She had transformed herself, and she didn't make a big deal out of it. She was doing it for herself.

**I wanted that metamorphosis—
that ability to change, to elevate, to be
a completely different person.**

After that, I started writing plays,
and I started acting
at ten.

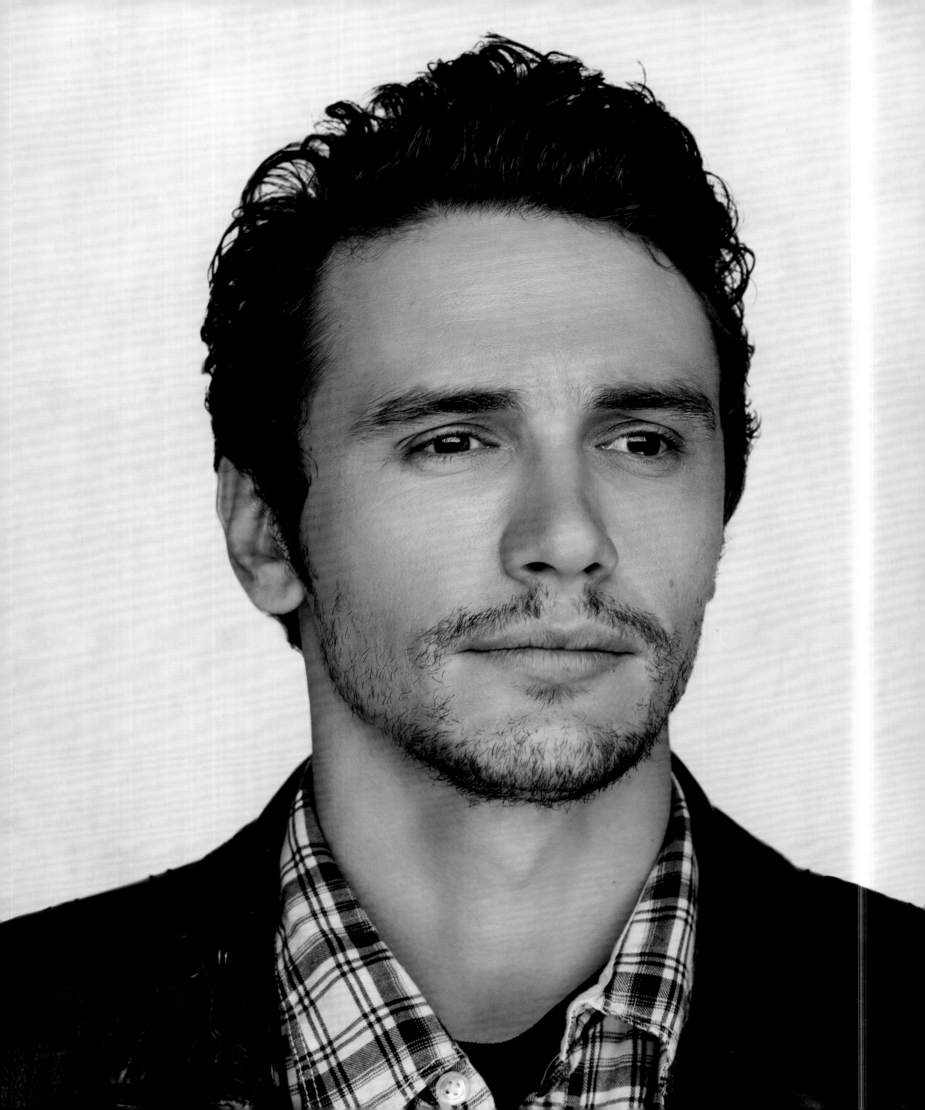

WHEN I WATCHED
Taxi Driver

WHEN I SAW
Paul McCarthy's *Sailor's Meat*

WHEN I HEARD
"The Best of the Smiths"

WHEN I SAW
Woman Under the Influence

WHEN I SAW
Requiem for a Dream

WHEN I SAW
De Niro in *Raging Bull*

WHEN I SAW
Nicholson in *Five Easy Pieces*

WHEN I SAW
Nicholson in *Cuckoo's Nest*

WHEN I SAW
Mike Kelley's *Day Is Done*

WHEN I HEARD
The Brian Jonestown Massacre

WHEN I SAW
The Dardenne Brothers' *The Child*

WHEN I SAW
Richard Prince's *"Gang"* Photos

WHEN I ACTED IN
Pineapple Express

Little Shop of Horrors

inspired me. My parents took me to see the local high
school's production when I was in elementary school. In my memory,
everything about it was world class, but I'm sure that's only
because it was one of the first things I'd seen onstage. The trio of girls
who narrate and harmonize their way through the show seemed
like superstars. I remember being home in my kitchen trying to do what
they did and failing miserably. At some point, I realized that they
probably weren't good the first time they tried the songs and dances;
it took them weeks of rehearsals and probably years of working
on their voices and bodies before that. I felt relieved. I could do
that, too. I'd just have to start working for it.

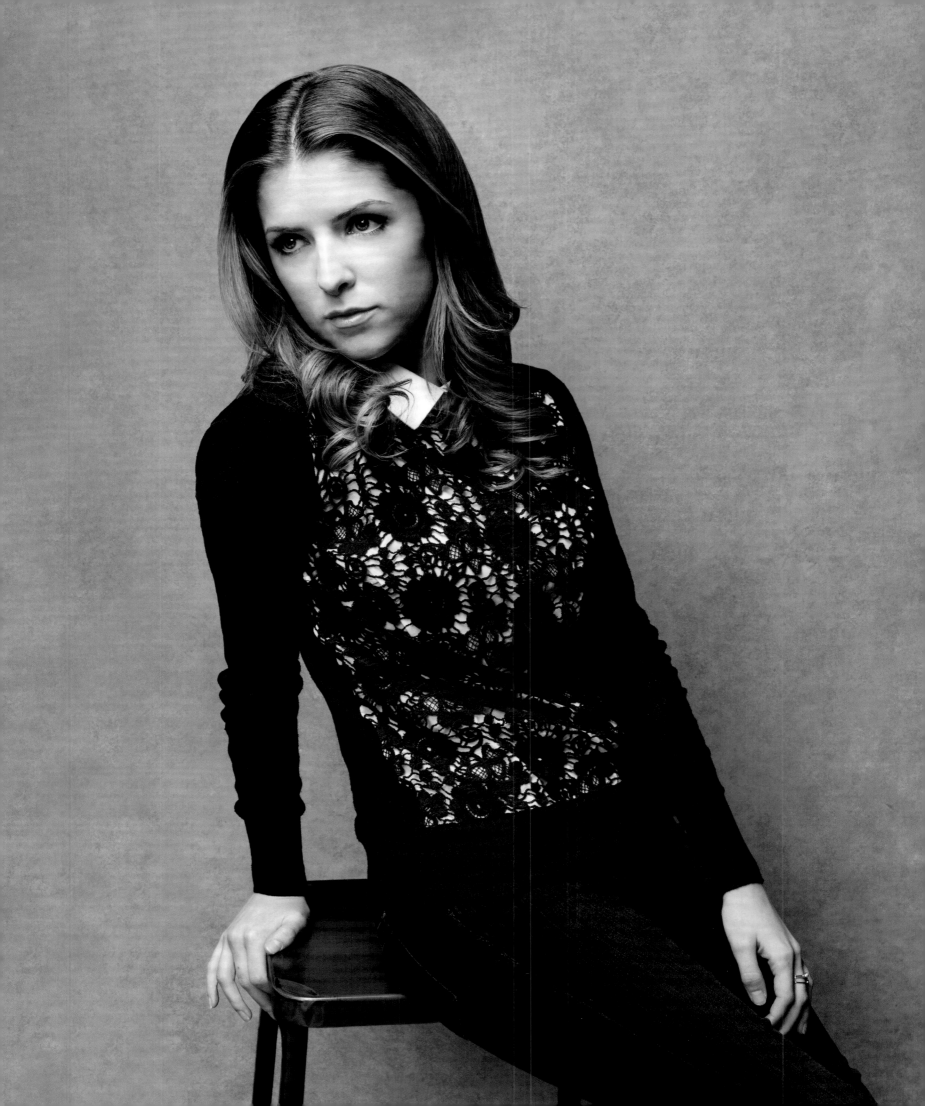

I WAS A

TEENAGER

and living alone in New York City. I didn't have a trust fund, and there was no father figure to save the day if I got into trouble. Being so alone was liberating. I could do whatever I wanted. Sure, I was broke and wondering how I was going to make my next buck, but I realized it was all on me to do the things that I wanted to do in life. That realization actually gave me an enormous sense of relief. It was my first aha moment, and then that's when I really started to rip up New York.

I remember walking down Broadway having just finished a job. I had made more than I'd ever made in one paycheck. It was powerful to know that I could pay my rent and eat whatever I wanted that day. I wasn't going to have to buy three-day-old bagels. I walked around Astor Place thinking "I could get a haircut, I could go to a restaurant, I could get the blue plate special at the diner." Anything was possible with a couple of bucks in my pocket and knowing, for better or for worse, that I was in control of my life.

I WAS MY OWN

MAN.

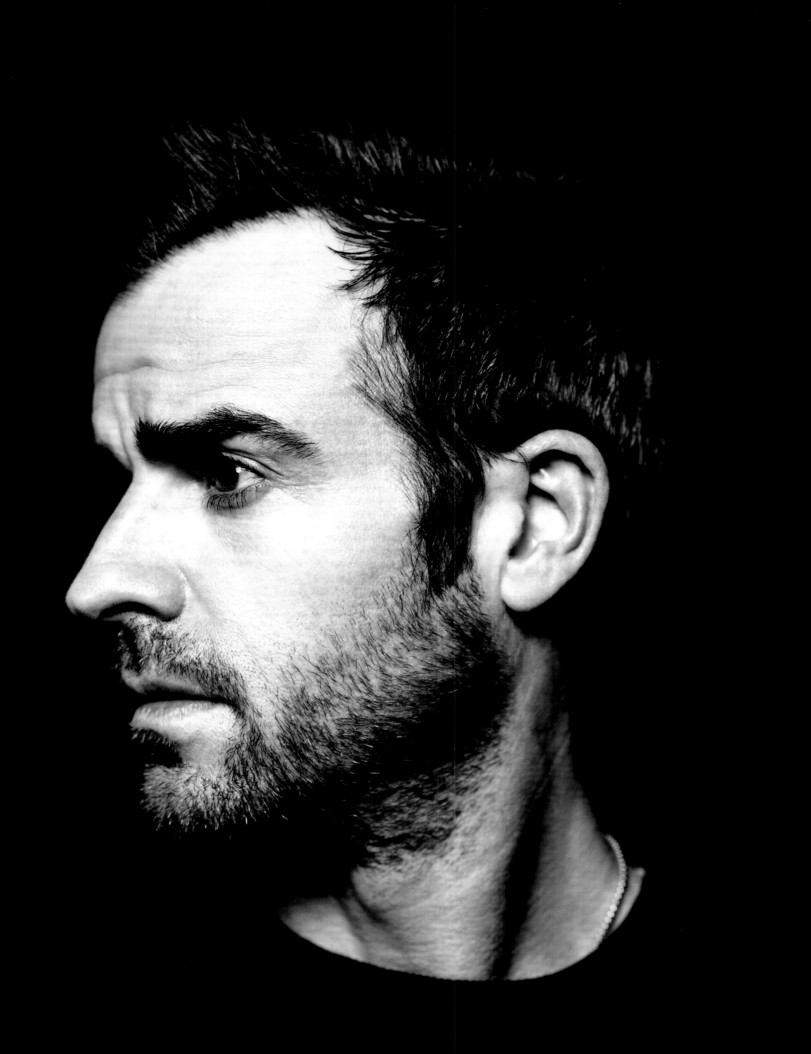

I'M REDISCOVERING
CLASSIC LITERATURE.
SALINGER'S GLASS FAMILY
STORIES, F. SCOTT
FITZGERALD'S *TENDER IS THE NIGHT*,
VLADIMIR NABOKOV'S *LOLITA*—
IT ALL BLOWS MY MIND.
THE SKELETONS
IN THE CLOSET,
AND THE CLEANING OUT
OF THOSE CLOSETS,
INTRIGUE ME.

JESSICA BIEL

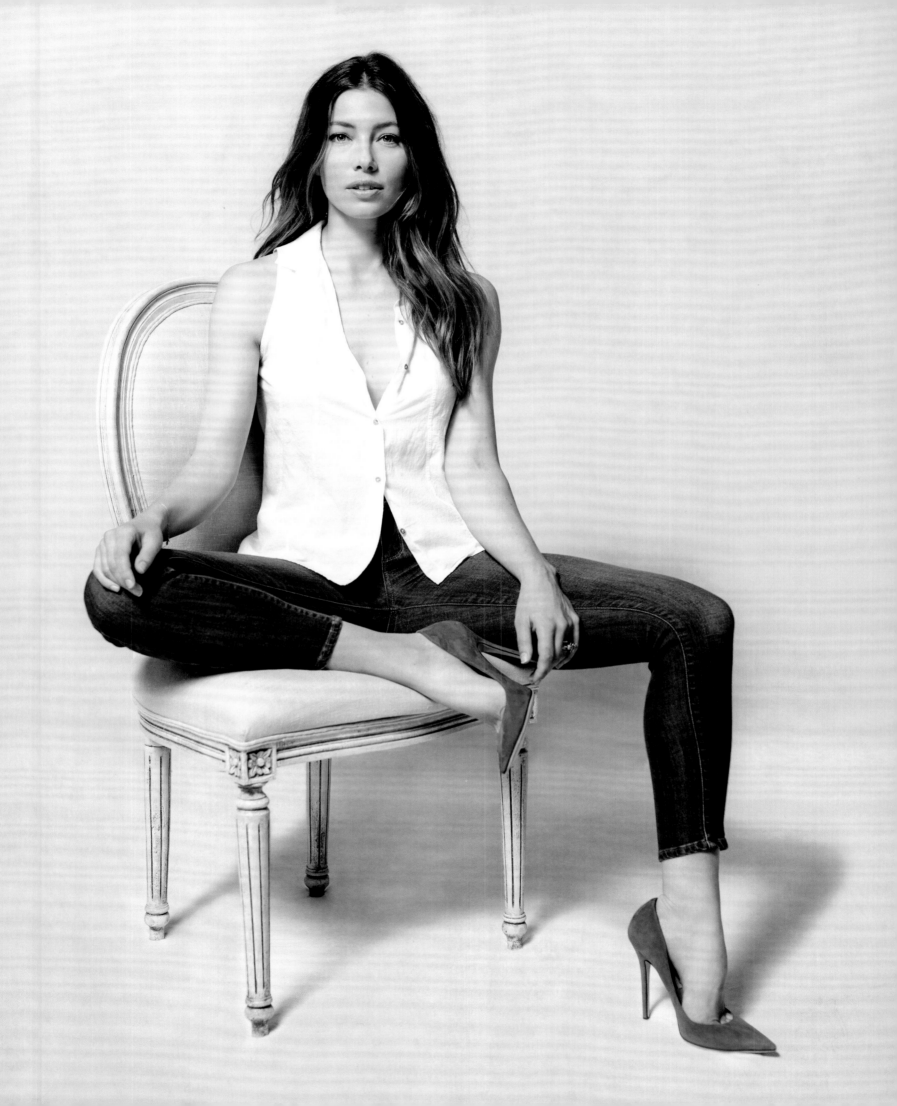

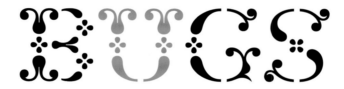

Bunny. What an actor. As a youngster, I came across an
image that shaped my understanding of what an actor could do. In this
picture, Bugs Bunny, Foghorn Leghorn, Pepe le Pew, Tweety, Sylvester,
Yosemite Sam, Speedy Gonzales, Daffy Duck, and Porky Pig stood side by
side on a painted stage, their heads hung low in silent reverence.
In front of them was a lone spotlit microphone, and below: "Speechless" and
"MEL BLANC 1908–1989." It took me a moment to absorb the gravity of
this tribute. He was one and all of them! I had no idea one person could be so
many. I burst into tears. Partly because he was gone and I couldn't
thank him for all the times he had made me laugh, but also for the feeling
that we can be anyone. That fella gave so much heart, silliness, and
insight into the human condition, the world will never stop smiling.

"Bedeh bedeh bedeh, That's all Folks!"

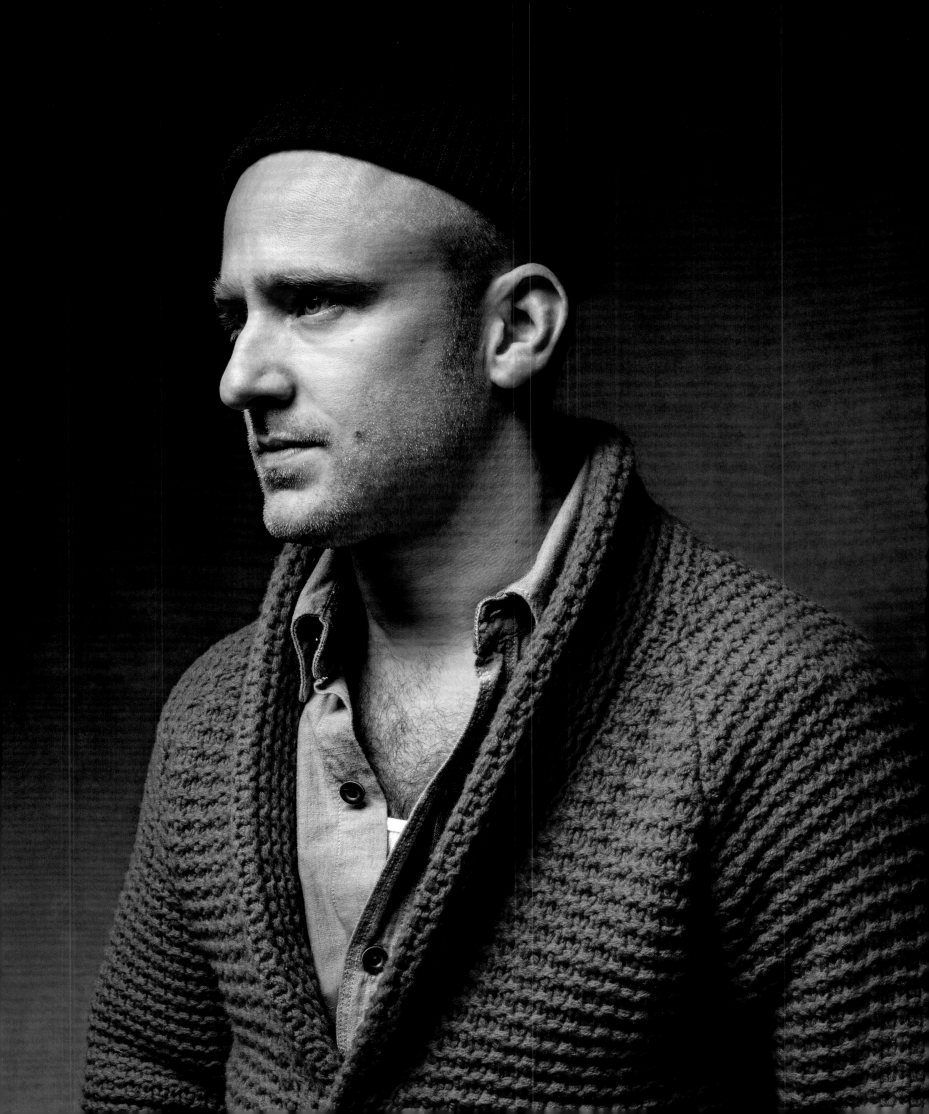

\mathcal{I} was 11 years old, and I had just completed my first little part in a movie. I knew I wanted to be an actor and had been on sets my whole life, watching my parents. I was in middle school walking through the hallways—treacherous territory. A boy said, "Hey, Dern, I heard that you didn't come over for that *hang* because one of the dads said 'There's no way that girl is coming over to our house, 'cause her dad killed John Wayne.'"

That just stunned me. I grew up with all the things that kids deal with who have well-known parents, but this was a whole new moment for me. It was understanding people's desperate need to live in a fairy tale and not really look at the reality of life. It all came crashing down in that moment. Someone wouldn't let his daughter be friends with me because my dad was a bad guy in a movie.

I'm my dad's daughter, and I have a rebellious spirit. My next thought was

"I'm going to play really complicated people, and let's see who my real friends are."

As my grandma would say, "I don't know how we can have a relationship and a friendship without the willingness to take the whole kit and kaboodle."

P.S. My dad told me a story recently. On the set of *The Cowboys*—the movie when he killed John, Duke said, "Bruce, you're going to kill me and, man, everybody is gonna hate your guts." It was the post-Vietnam era and my dad said, "Oh yeah, Duke? Well, in Berkeley I'm gonna be a hero."

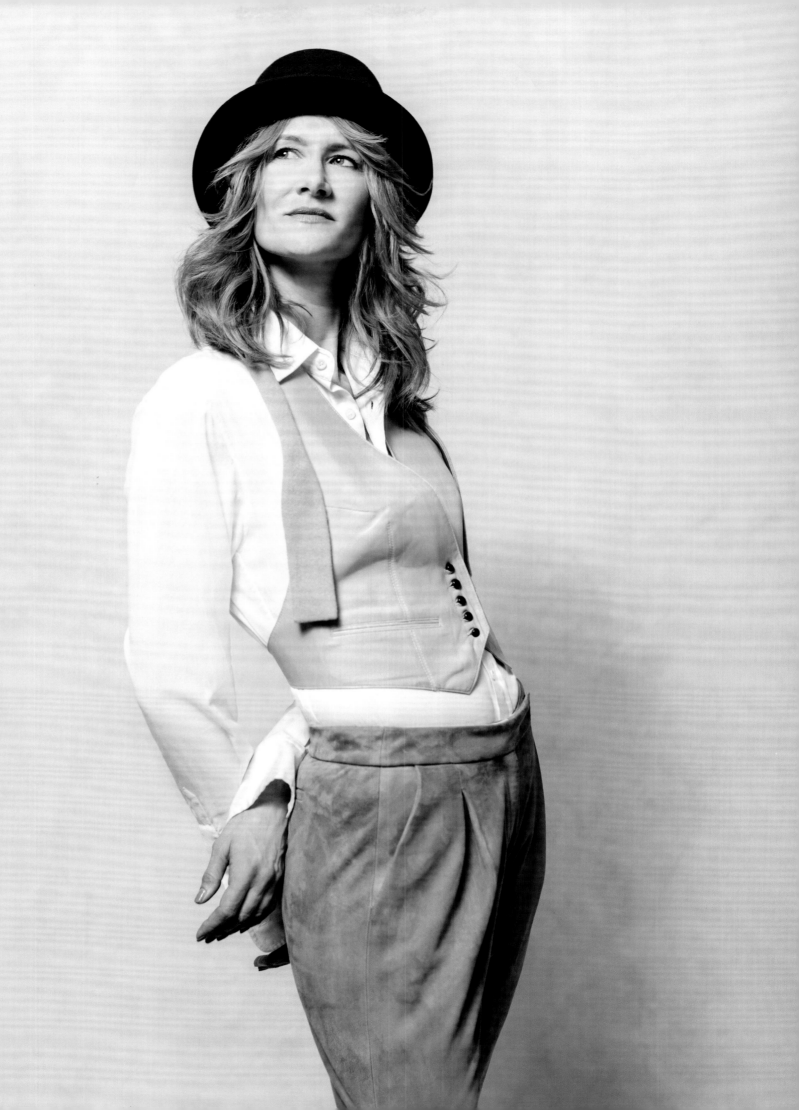

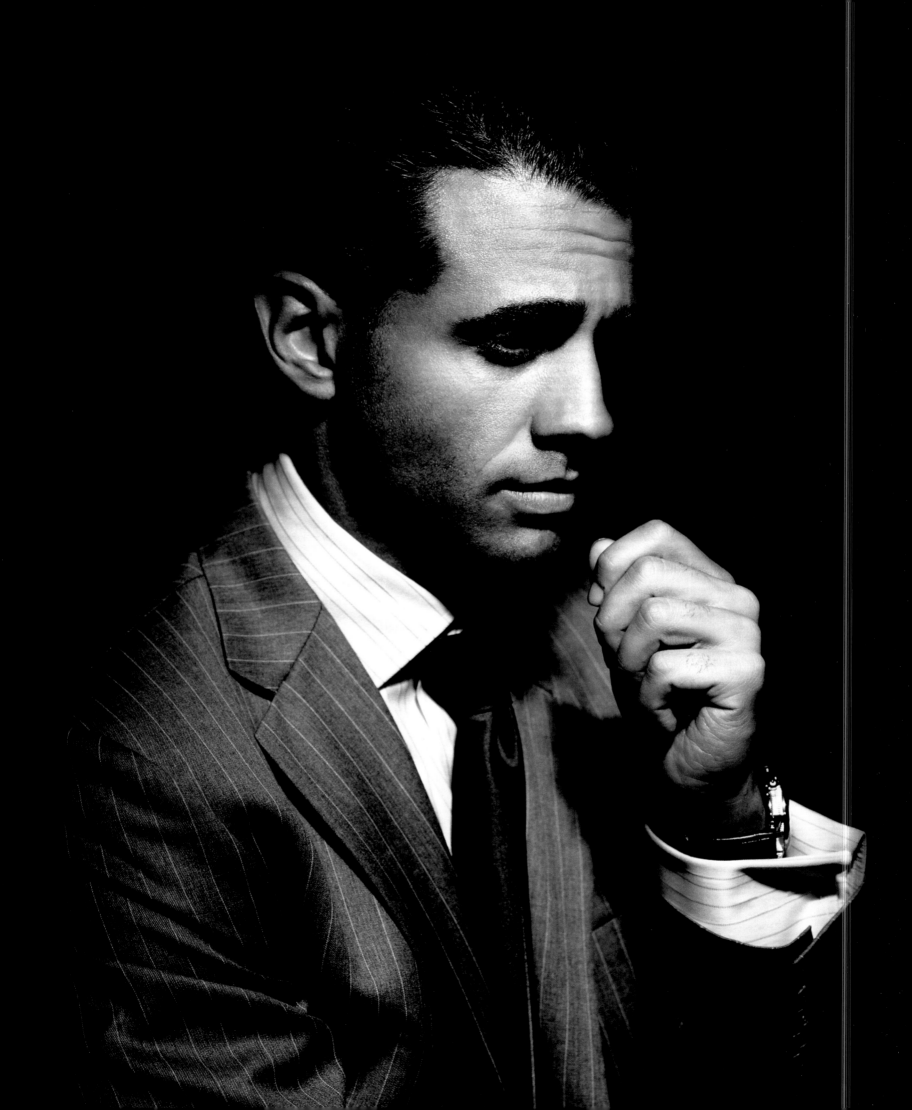

I got cast in my
local church theater group's
production of

when I was ten years old. I had to beg to be cast as a gangster.
This was an adult production, and I worked so hard to convince the director
that I would work really hard to portray *fourth gangster from the
right* and that I'd be funny. I worked very hard. I liked being out of my boring
family home life and surrounded by grown-ups who really wanted
to be where they were, creating this thing—my first job. Also, I was right.
They laughed their asses off. Every night.

It's not about how you look, but what is inside you.

Seeing Anthony Hopkins
onstage at the National Theatre
in *A Woman Killed with Kindness*
was the single most profound moment
in my youth that convinced me to become an actor.
His vocal tones, his physicality
were authentic and plausible.
Onstage, Hopkins was a man who
looked like he had just walked off the street.
I believed I could hear
him thinking.

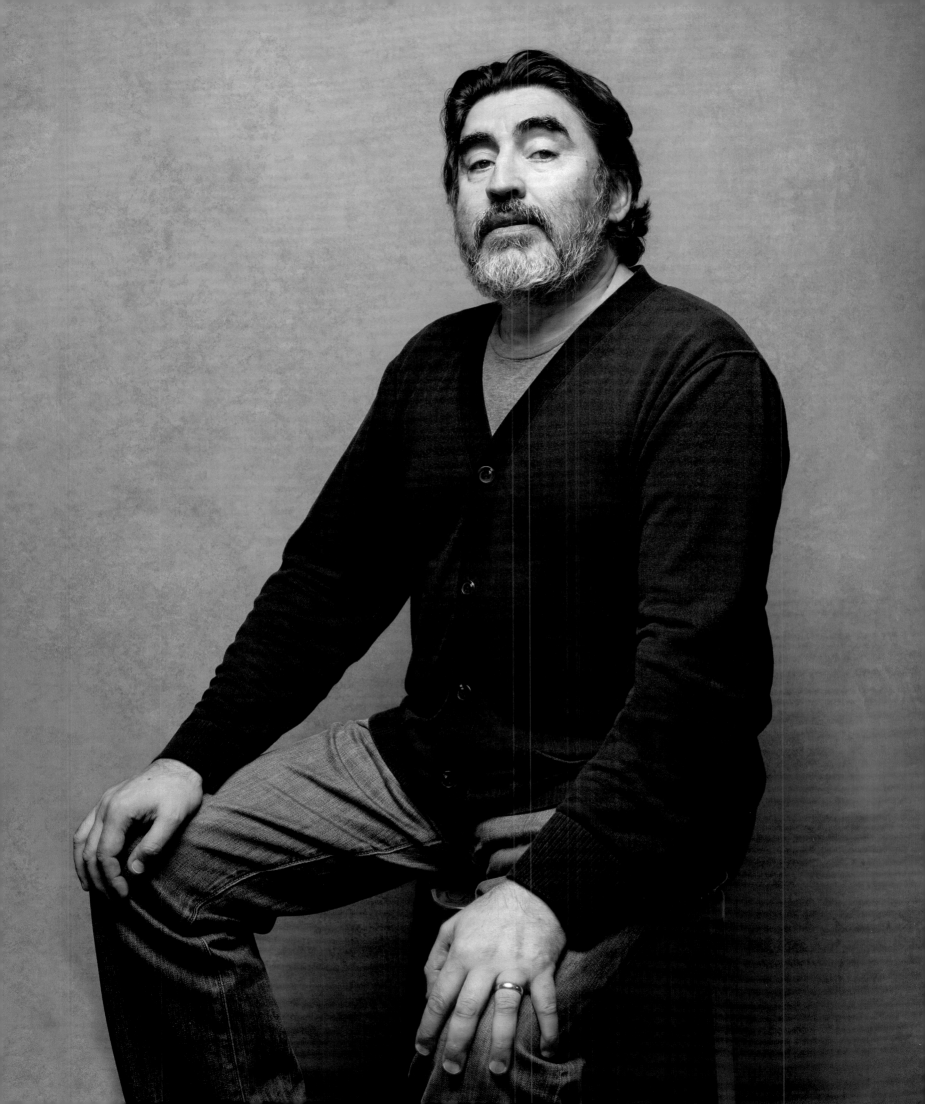

i grew up in a small town along the
Gulf of Mexico in Florida. I remember
doing a scene in **drama club** that was **serious**
and dramatic, and everyone started
laughing. It really irritated me that I was
seen as a **class clown** and
not a serious actor. I started working on my
dramatic abilities after **that day.**

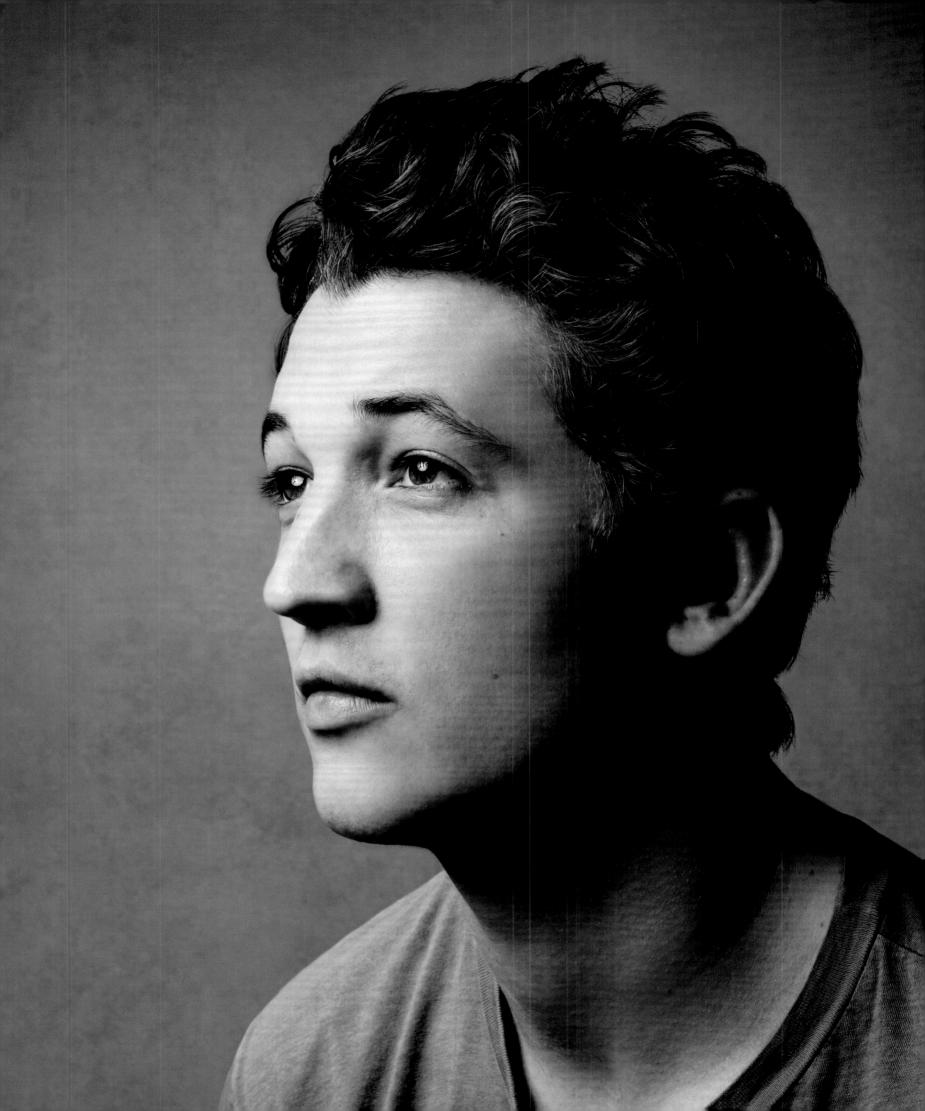

BEFORE I LEFT TO START FILMING IN

MOROCCO,

EVERYONE WAS OFFERING THEIR OPINIONS—WARNINGS, RE-
ALLY—THAT BECAUSE I'M A WOMAN, I SHOULDN'T TRAVEL THERE
BY MYSELF. IT WAS FUNNY, BECAUSE I AM A SEASONED TRAV-
ELER WHO GOES WITH THE FLOW WHEREVER I AM, I CAN FIT
IN PRETTY MUCH ANYWHERE. IT WASN'T LIKE I WAS PLANNING
TO WALK AROUND IN A MINISKIRT, POPPING MY GUM, AND
SCREAMING AT PEOPLE IN AMERICAN ENGLISH. IT WAS AN IN-
CREDIBLE EXPERIENCE. BECAUSE I WAS THERE ALONE, I GOT TO
GO WHEREVER I WANTED TO GO. I WALKED THROUGH THE MAR-
KETS THAT WERE HOME TO MONKEYS AND SNAKE CHARMERS,
WHERE WOMEN SOLD KOHL EYELINER AND LEATHER GOODS,
AND STALLS WHERE PEOPLE MADE KNIVES. IT WAS BEAUTIFUL.
I HAGGLED WITH A GUY OVER THE COST OF SOMETHING AND,
THOUGH WE COULDN'T AGREE TO A PRICE, WE SAT DOWN
AND HAD TEA TOGETHER. THAT'S WHAT'S IMPORTANT: REC-
OGNIZING WHERE YOU ARE AND ENJOYING IT FOR WHAT IT IS.

You
can go to therapy.
You can buy a new outfit.
You can have lunch
with your friends,
and have a very nice life.
I was more afraid
of being stagnant than
I was of failing.
It's okay to step forward
and not know where
your foot is going
to land.

I was researching a character for *Red*, a play I was
doing on Broadway, in which I played an artist's assistant.
I stumbled across a quote by the artist Dan Rice, who
had been Rothko's assistant in New York in the late 50's.

"IT IS THE GRIND AGAINST ONESELF THAT MAKES AN ARTIST, NOT TALENT AND ALL THAT.

It's the internal vision of what is possible to be
achieved and the unwillingness to settle for less. *To get it
right just once... knowing you never will.*"

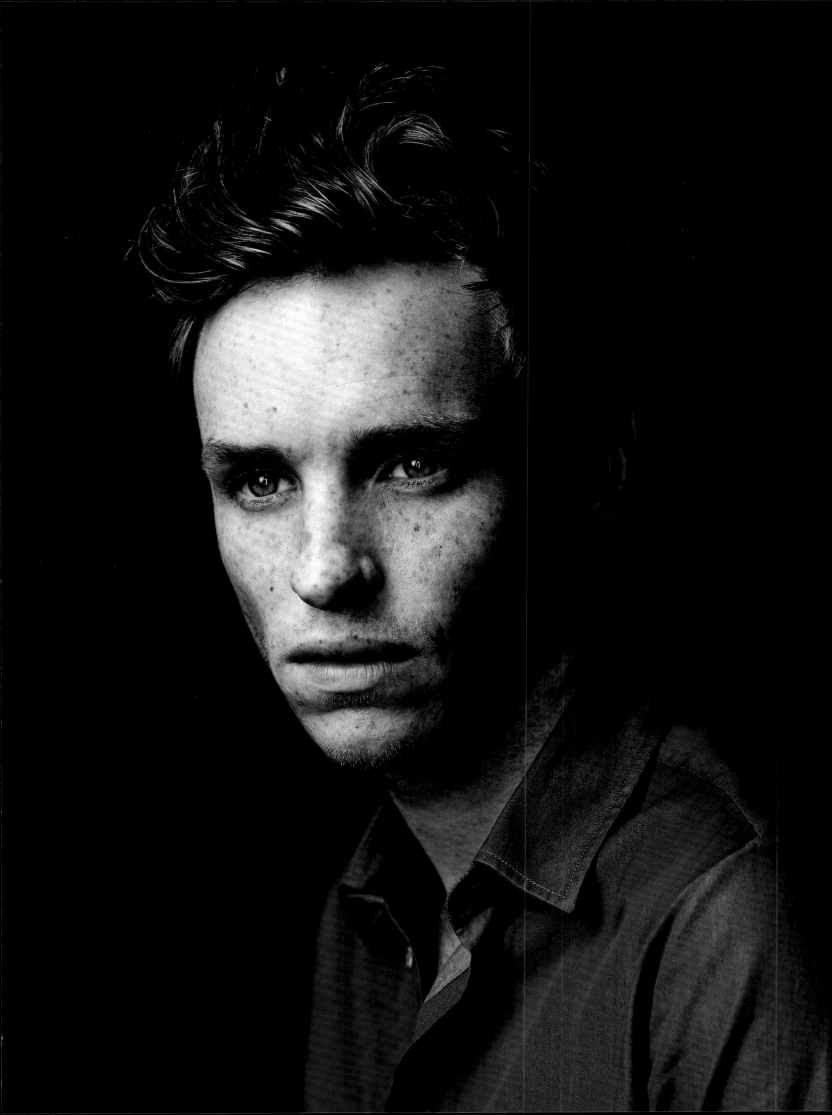

Watch the birdie, the camera is not a birdcage. There is no bird in the picture, there is just me.

I had just turned

EIGHTEEN

and was going to live in New York City
on my own. The day before leaving,
I went to Disneyland. I sat in
the New Orleans-inspired restaurant
eating a deep-fried ham and
cheese sandwich (*don't ask*), while
wearing sparkly Minnie Mouse ears
(*as one does there*). I faced a
moment of discovery. I would change
after moving to the big city
on my own, but I would always make
sure to go places to bring out
my inner kid.

I WAS CURLED UP ON THE COUCH IN
MY FADED-PINK PLAYROOM, TAKING A BREAK FROM
CRAMMING FOR MY HISTORY TEST. THE ROOM
NOW LOOKS MORE LIKE A COLLEGE DORM THAN A
CHILD'S SANCTUARY. POLLY POCKETS AND
CARE BEARS STILL LINE THE SHELVES, BUT TEXTBOOK
CLUTTER HAS TAKEN OVER MOST OF THE SPACE.
WHILE I LAY THERE, I THOUGHT BACK ON THE DAYS
WHEN I DIDN'T WORRY ABOUT THE GRADES.
I WORRIED ABOUT MY DOLLS GETTING ENOUGH
SLEEP AND ABOUT SETTING ALARMS TO MAKE SURE
I WOKE THEM UP IN THE MORNING ON TIME.
I LOUNGED ON THE COUCH FOR A WHILE, STARING AT
THE CABINET WHERE MY DOLLHOUSE FIGURINES
RESTED. THEY HAD NOT BEEN WOKEN UP IN A WHILE.
I WAS ABOUT TO OPEN THE CABINET DOORS,
BUT INSTEAD REMEMBERED THAT I HAD NOT STUDIED
FOR THE MAP SECTION ON MY TEST. THE DOLLS
STAYED SLEEPING, WHILE I DISCOVERED I WAS

GROWING UP.

"I SOUND MY

BARBARIC

YAWP

OVER THE

ROOFTOPS

OF THE

WORLD."

I was 18 years old when Robin Williams read this Whitman
quote to me, as we filmed *Dead Poets Society*. My character was supposed
to sound his YAWP for the class. It was early in the shoot, and
the first time I ever felt the real heat of a collective creative collaboration.
I've been chasing that YAWP ever since.

ONE WALK AROUND A FOOTBALL FIELD IN THE SOUTH OF SYDNEY CHANGED ME. ONE WALK.

While rehearsing for my first lead role in a feature film, *Somersault*, I walked around the local football field. I threw myself into the deep end of my character, Heidi. Walking around that loop became an insightful journey into me. To trust, to be, to move, to connect, to be fearless.

I was in college near Liverpool and read a notice from a neighboring
all-girls college calling for men needed for a stage production.
I was training as a painter, but this was a very attractive notion. I didn't quite run
to the college, but I got there quick and signed up. A professor spotted me,
and simply said, "I think you should act." He sent over the papers, coached me
through two auditions for the Royal Academy of Dramatic Art,
and changed my life. If I hadn't gone down the road, I would never have had
the life I've had, never experienced the power of theater and film.

ALL TO
DO
WITH
GIRLS.

At 18, I shared an apartment with five other people in Culver City and had very little life experience. Rent was due and I was auditioning a lot. I had no alternative—no backup, no savings, no parents to call who could bail me out, no friend to loan me money. There was more and more pressure to land something. It was the end of the month and I went for something cheesy and terrible. I fought for it because I needed to feed myself. I didn't even get that audition. I was devastated and very worried about where the next paycheck was going to come from. It struck me how unreliable my chosen profession was. How scary and personal the losses felt, and how intimate the rejection felt. At that moment, I realized I had no other option than to make this work. My alternative was to return home and give up. I sat on my couch and I looked out the window and I realized I had nothing else. This was the do-or-die moment. I ate Ramen noodles for a long time and then I landed something and have worked ever since. My inspiration is that sometimes there's no alternative, there's no other plan. In this industry, I think we're always chasing the high—the warm glow of an escape, a relief of creatively disappearing. It's electrifying.

AMBER HEARD

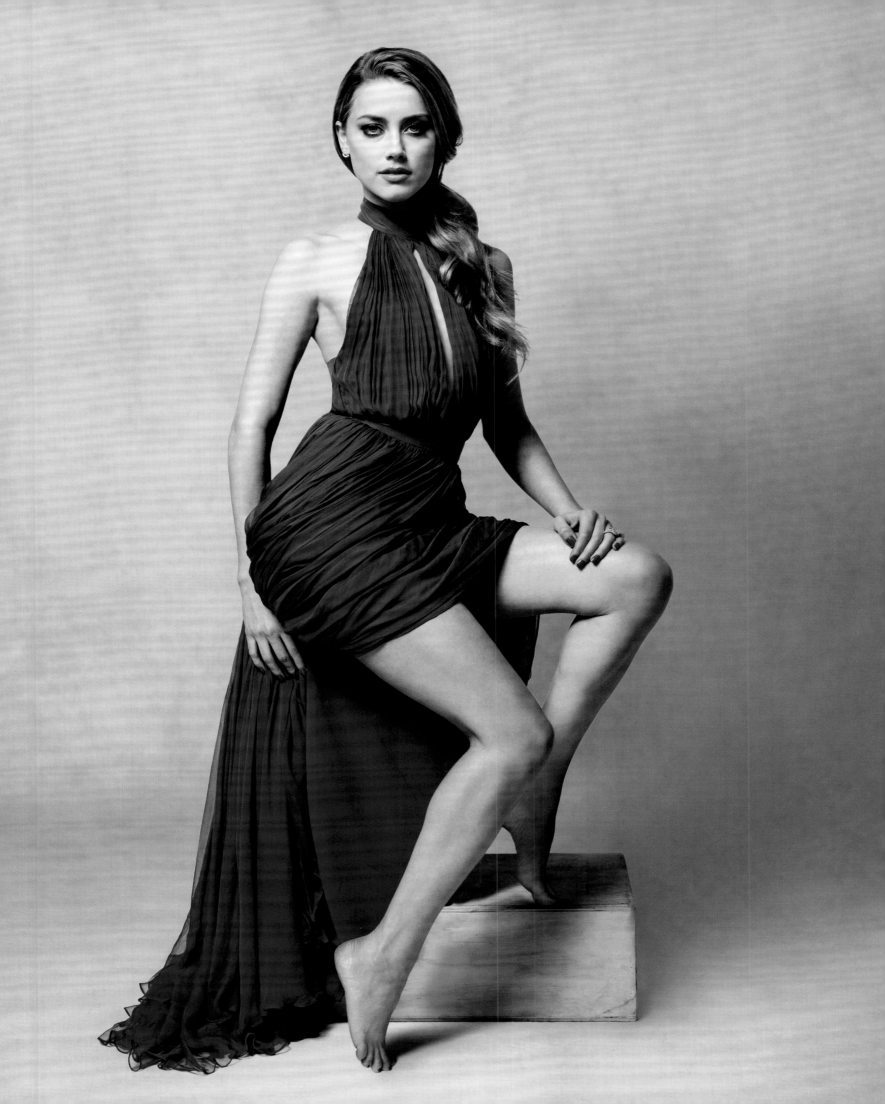

I was working with Danny Boyle on *127 Hours*.
We were doing a scene and we shot numerous takes
because there seemed to be someone laughing
from off-camera. We couldn't figure out who it was, and finally
discovered it was Danny. He loses himself in the work
and is completely unashamed of being passionate about it.
To see someone so successful and talented behave
with just as much excitement as he probably
did when he made his first film, inspired me to be open
and honest about the joy acting brings me.

Being cool
about it all is overrated.

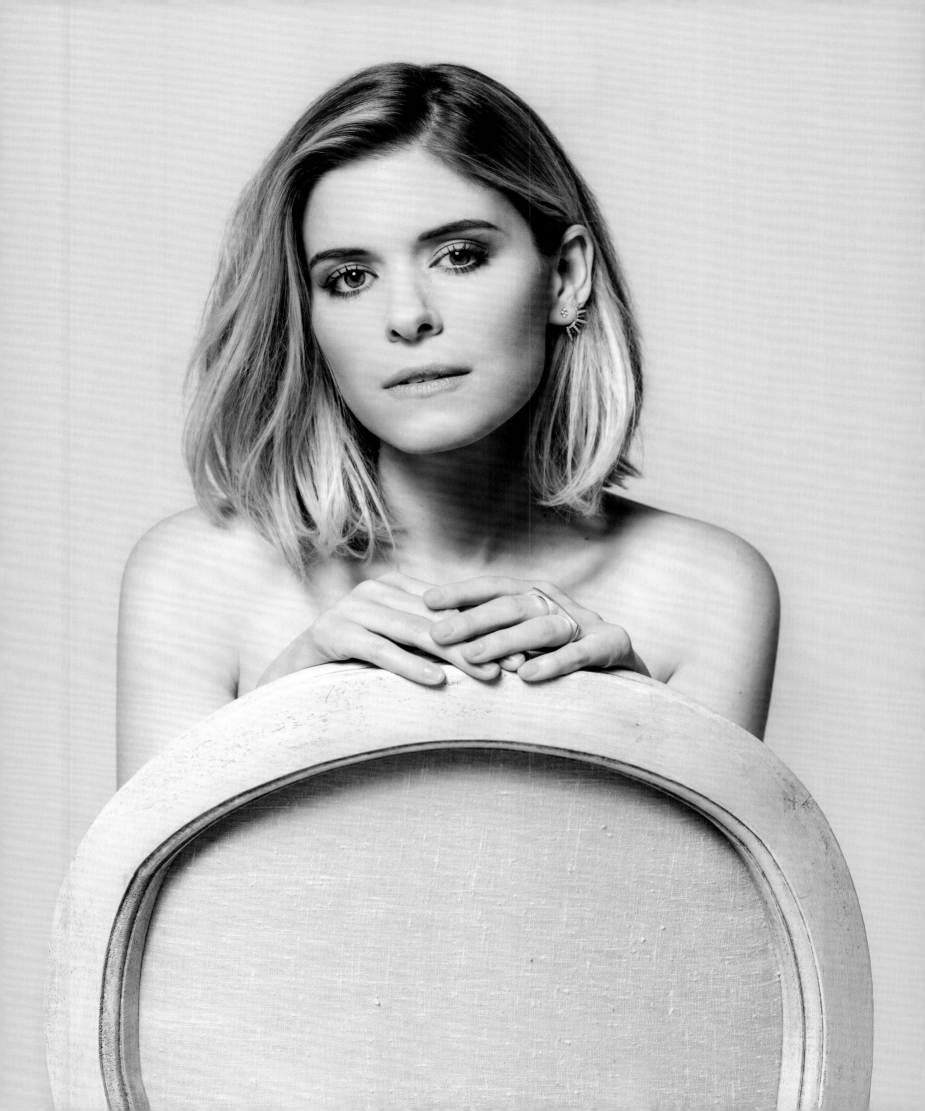

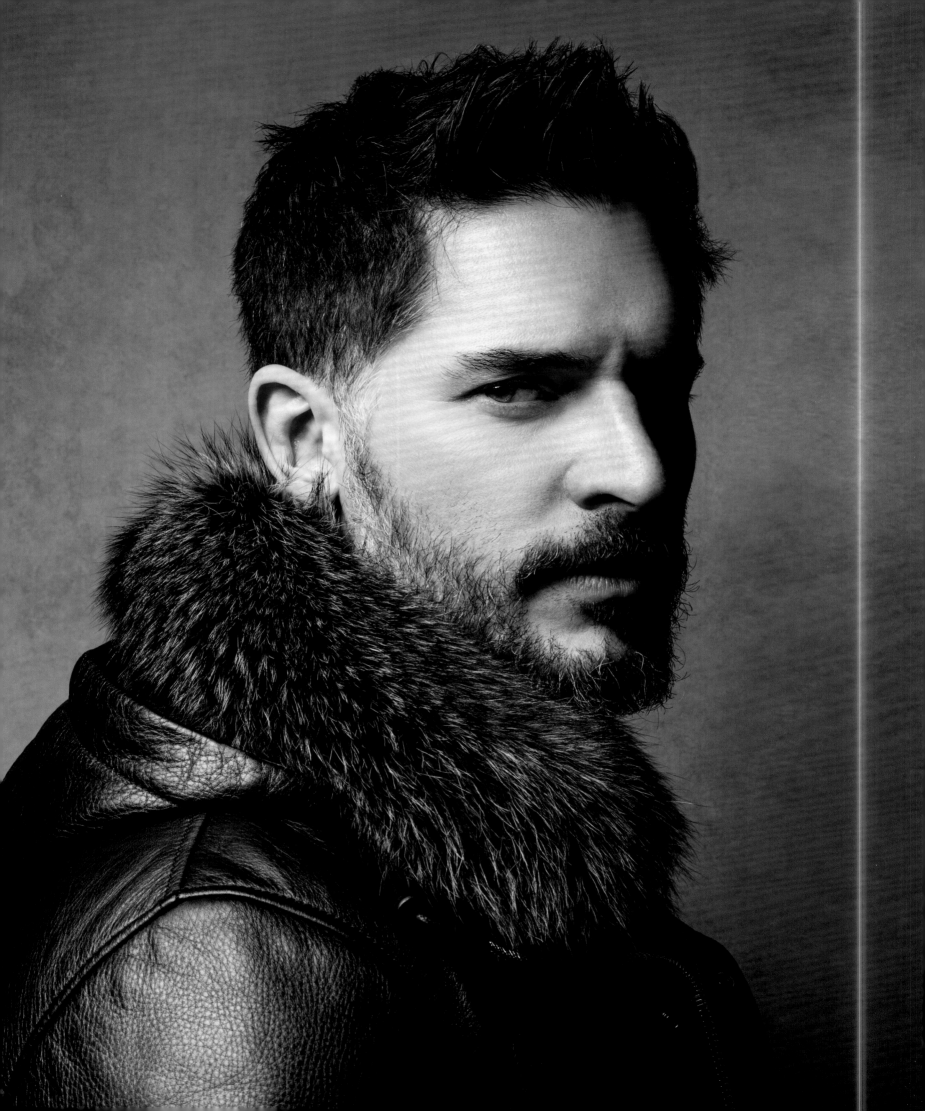

My
father said if you don't
play football, then
you won't do anything. I said
I'm not playing football.
I hung up the phone
and was on my own. I knew
in my gut, I knew in
my heart, I was
willing to fight to create
and to be an artist.

I WAS 16

AND LIVING WITH DON, AND HE SAID
"GO DO SOMETHING—HELP US MAKE SOME
MONEY." I NEVER EVEN WANTED TO BE AN
ACTRESS. I WAS A MODEL AND GOT SENT ON
AN AUDITION FOR *NIGHT MOVES*, WHICH
TURNED OUT TO BE THIS HUGE MOVIE.
THE DIRECTOR, ARTHUR PENN, WOULD STAND
BELOW THE LINE OF THE CAMERA AND
MOVE MY BODY BECAUSE I WAS SO FROZEN.
HE AND GENE HACKMAN TAUGHT ME
SO MUCH. THEY WERE SO PATIENT WITH ME.
ARTHUR WAS MY BEGINNING, AND THE
SPARK OF DISCOVERING WHAT I KNEW
I SHOULD GO TOWARD.

I remember watching Richard Pryor
when I was a teen and seeing what power and
freedom and joy he had, and was
transmitting to me and everyone I knew.

Lily Tomlin, Spalding Gray, Eric Bogosian,
and Whoopi Goldberg also set me free. I felt they
passed an unspoken baton and said,"Now you,
do you." I feel that as artists, we do that — we
open paths and set others on life missions to make
our lot comprehensible and tolerable.

I HAD A VERY DIFFICULT TIME WHEN MY SON WAS BORN. HE WAS VERY, very sick. The doctors said that he just wasn't going to live for very long. I remember listening to Donna Summer's song, "On the Radio," and it was such a strange juxtaposition to what I was feeling.

Everything made perfect sense and no sense.

All I wanted to do was to have some power, God or somebody, to make me sick and make my baby well. I realized that was as incongruous a thought as listening to this disco song and looking at him. I just didn't know what to make of it except that I just so deeply wanted my son to survive. It was connected to a disco song, and that was completely bizarre. It made me understand that everything is connected, and sometimes nothing makes sense. It inspired me to try to understand that about life. To accept it, roll with it, and embrace the idea that life's going to go wherever it's going to go. It's not going to be a movie where you put the perfect song with the perfect moment. My son is now 33 years old and finishing up work on his PhD in religious studies. Of course, I think he'll finish his PhD and then get into show business.

I WAS 16 YEARS OLD, THE TIME WHEN A LOT OF YOUR FRIENDS
are home all summer and going out and going to parties. I had to have
a convertible, but my parents were not going to buy me one,
so I saved up every penny to get a convertible, any kind of convertible.
I bought a 1985 Saab turbo convertible that broke down all the time.
And that's what made my mom decide to send me to apprentice at the
Williamstown Theatre, a summer stock program in Massachusetts.
I was immersed in the arts—acting, writing, building sets.
I was part of a community of writers, actors, and songwriters.
It was the first time I felt part of a community of people who also loved
to tell stories. We staged theater everywhere, from the forests to local cafes.
We would rally around each other and support everything from one
another's small shows to the big productions with very established actors
and actresses. It was like I had become part of the traveling circus.
It was there in Williamstown, I discovered that putting on any production
was the result of a collaborative effort. No matter what's happening on
the stage or in front of the camera, there's a complete and total symbiotic
relationship with what's happening behind the production. One cannot
create without the other. Everything about that experience inspired
me, and now, every time I go to make a film, it's the collaborative effort
that inspires me to do my best. It is knowing that everybody has
specific jobs, but we're all there to create a piece of the same end project.
I also realized there that this world of the performing arts
was one in which you can create amazing relationships and one-of-
a-kind shared experiences. And then you have to say good-bye.
That impermanence is a great metaphor for life:

nothing is permanent,

but what we take from one experience is what
we can give to the next one.

One of my best
friends, who is 75, said
to me one day, we

SQUANDER

our hours of pain.
It's something
I want to tattoo on
the small of my back.
There's a way to
live through it and
have it be amazing.
Pain is part of
being alive.
Thank God I'm alive!

MY FIRST REAL LOSS IN LIFE WAS WHEN MY BOYFRIEND PASSED
away. I was a teenager—a kid. I remember standing on the corner
of St. Marks and Third Avenue in New York City really early in the morning.
People were eating bagels, walking by with coffee, getting in and out
of cabs. They were living life and mine had stopped. I couldn't understand
how someone's life ended, and yet everyone kept going about their day,
as if nothing had happened. Everything that had any sort of importance
to me was gone. Time stood still, and I realized I had two choices.
I could go home and feel like I wanted to die, or make this mean something,
something greater than I had ever experienced before. It was a
collision of complete silence and chaos. I went about my day and realized
how life kept moving, even though everything inside of me felt very, very,
very still. As time went on, I started to discover that his passing allowed me
to relate to the truth of life and death, the idea that at any moment,
that which you love the most can be taken away from you. And ultimately,
that's what unites us all. We all live and we all pass. I turned something that
was probably the worst thing that had ever happened in my life into

THE GREATEST
GIFT
OF DISCOVERY.

We all have a choice: to either lie down and die or stand up and use each
profoundly tragic or disturbing experience as a greater gift for
the world. It was that sharp pain of the awareness of mortality that brought
me my life, my child, my family, and my career. Every day that I go to set,
I know that it all stemmed from that moment.

AFTER I MOVED TO LOS ANGELES TO BE A CAMERMAN, I STARTED TO ACT, AND REALLY GOT INTO CHARACTER DEVELOPMENT. BEING ABLE TO DIVE INTO THESE OTHER PEOPLE'S HEADS IS LITERALLY AN ADDICTION. IT'S LIKE SMOKING AND TRYING TO GIVE IT UP. IT'S NOT BEEN EASY.

I learned about fragility when I was eight years old. My father passed away and I saw my mom, a person you can push, push, push, just break down. It was heartbreaking. I was scared, but, at the same time, I felt enlightened by the realization that someone on whom I was relying was fragile herself. There were so many questions popping in my head, and I had no answers. Learning that we're all breakable gave me a sense of identification with, and compassion for, other people— a sense of consciously approaching how I would handle things, and how I want to be handled.

I learned that I don't want to act all the time; I want to interact, and in order to do that, I have to listen, take, and, of course, give.

I COME FROM MODESTO,

California. Not knowing what the hell I wanted to do, my dad told me to go to the local junior college and figure it out. That gave me a lot of freedom. My dad gave me permission to fail, and he didn't put any expectations on me. He told me to play around, go explore, see what I hate, see what I love. So I just went out and tried. I studied DOS and other computer languages, but I realized I didn't have the personality to sit behind a computer for the rest of my life. So I shifted. I thought maybe I wanted to be a cop or a detective, and went into criminology. At the same time, I took an acting class and got my first paid acting job. It was at the local junior college where they needed actors to play criminals to help police officers in training. They put me in a room the size of a closet and said, "Someone's going to arrest you, do everything you can to not be arrested." They closed the door, and a little while later this guy comes in. He's kind of scared and says, "Excuse me, sir, is anybody else home in the house with you?" I kicked and punched him, and they gave me my 50 bucks and sent me home.

T was probably a few months behind on my rent and my landlord was threatening to evict me when I met with David Lynch. It was not a good situation. David saw through the nervous demons that I was carrying around with me. I remember it vividly. He never asked me to read; he talked to me. Normally, there's barely eye contact with a director at an audition. And he really wanted to hang out. He was smiling, and there was a light beaming through him that put me at ease. I felt like I was being seen for the first time. This guy unveiled me in a way that made me feel safe enough to show who I was. I was just me, and that was okay with him.

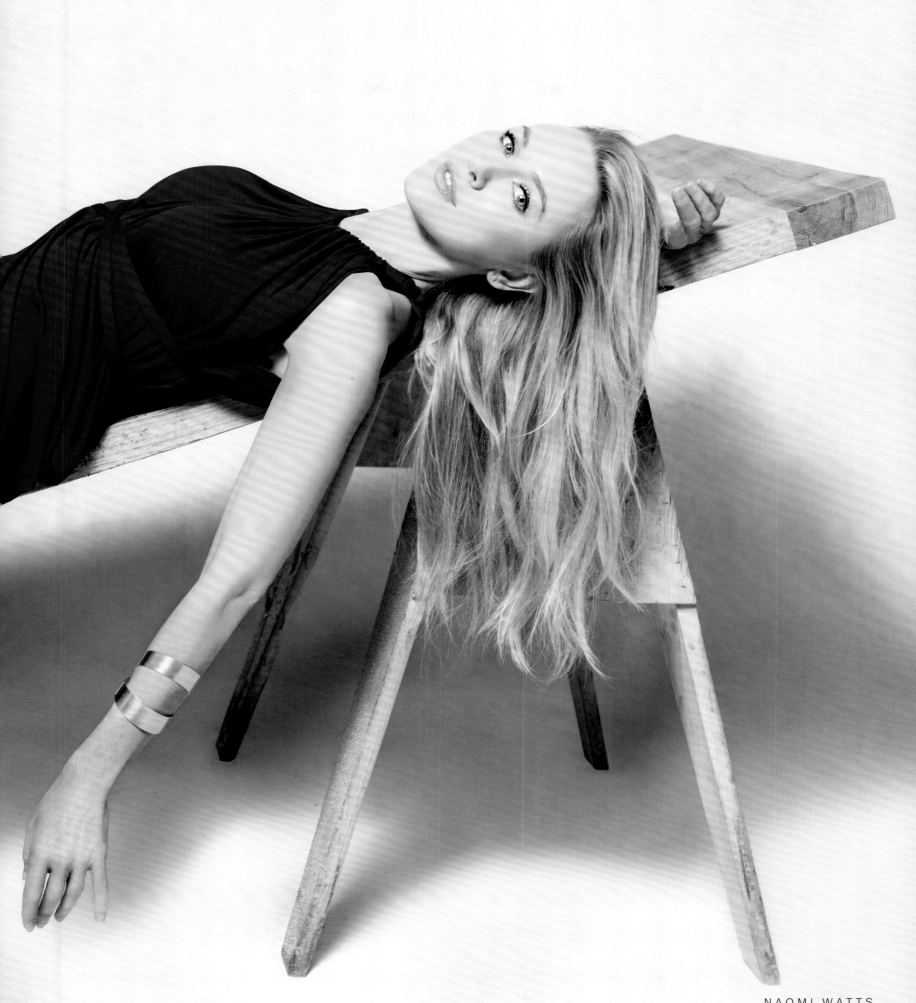

NAOMI WATTS

I went to see *The French Connection* while still in school. Gene Hackman became, and remains to me, the gold standard when he said, **Oh come on Herb, What the hell's a rocker panel?!** I experienced as pure a pleasure as I've ever known with my clothes on.

WILLIAM H. MACY

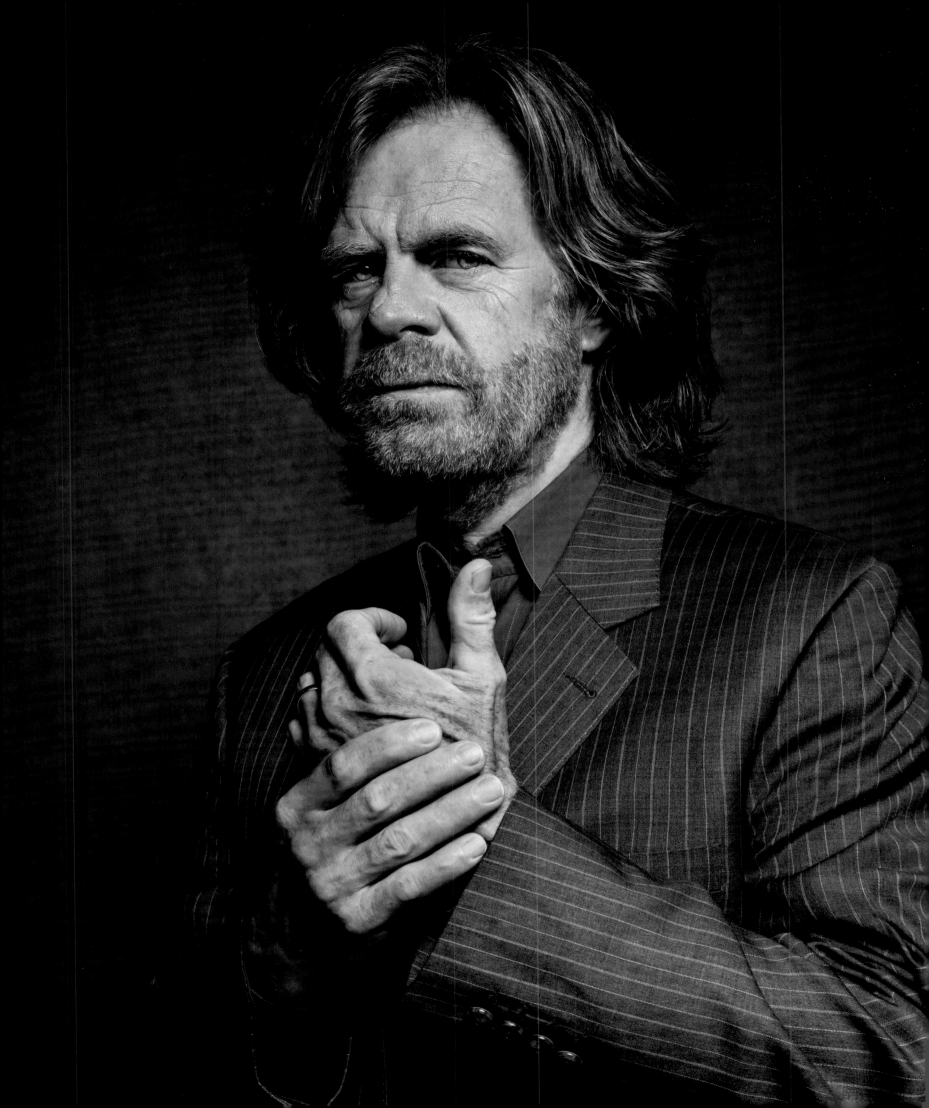

I went to an intensely academic school and, even though I liked it, I always felt like the weird, artsy girl. When I was seven, my chorus director sent me to audition for the New York Metropolitan Opera Children's Chorus. I had to sing happy birthday in ten different keys.

Six weeks later they pushed me out onto the stage in *Die Meistersinger von Nürnberg*. It was a very adult production and all about singing Wagner the way he wanted it sung (I was just hoping to remember not to pick my nose onstage).

I walked into bright lights, with intense German music playing, and live animals—horses and donkeys onstage, and all those fancy people dressed in fur stoles in the audience. I remember thinking, *This is right. Everything feels right.*

I'm surrounded by a bunch of people who are crazy, and weird, and love the same thing I do.

And, finally, I don't feel like the odd man out. I feel like I fit in. I love being part of something so big and alive. I feel right in my body. This is what I'm supposed to do—be creative, play, pretend, imagine, and tell stories through music, words, and art. It felt immediately right and there was no other thing that I could ever possibly do.

There were no second takes.

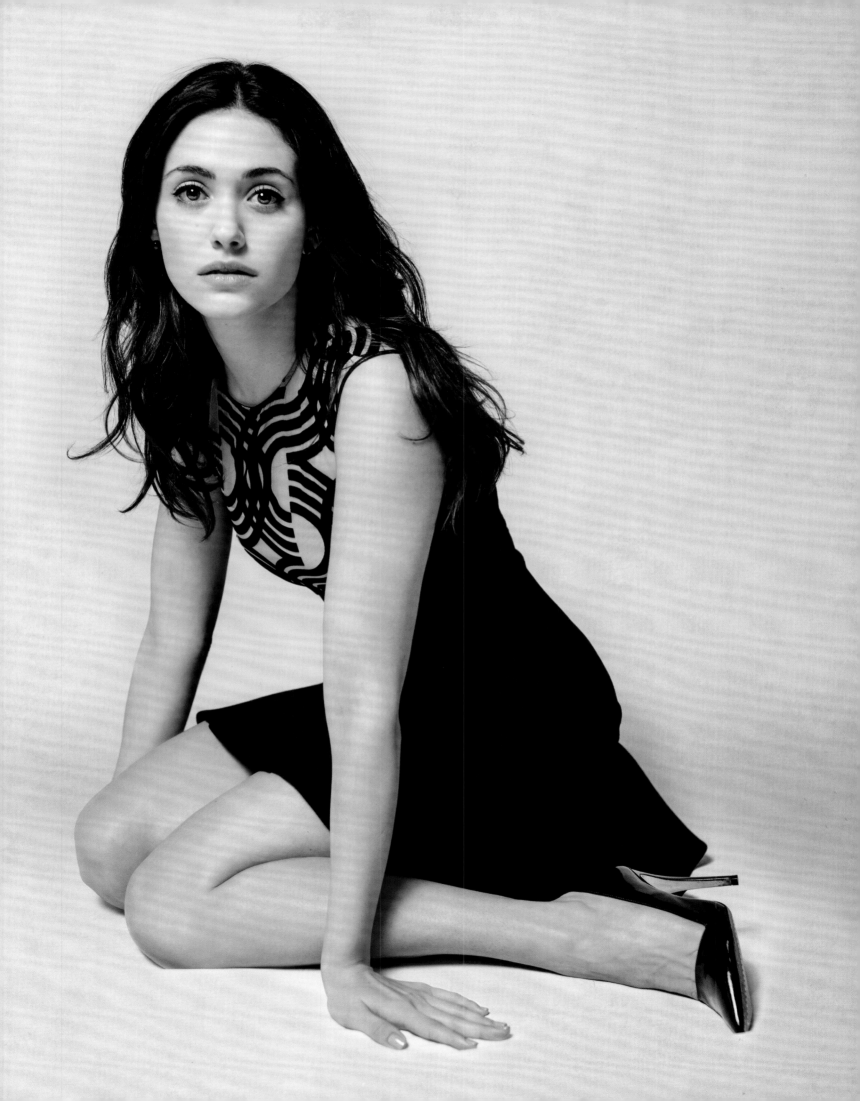

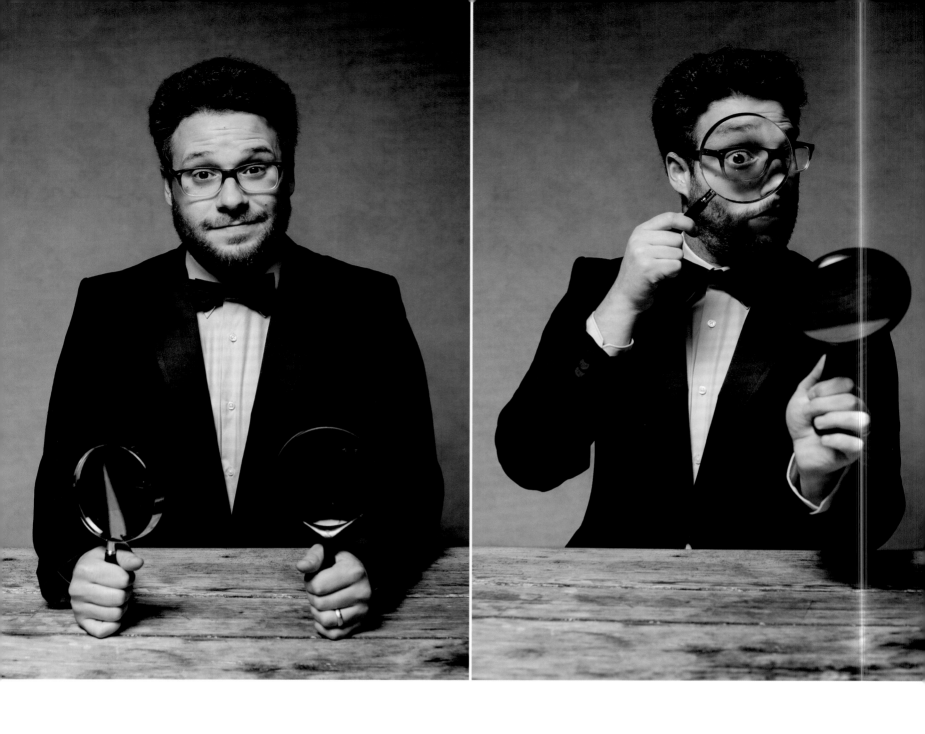

I STARTED DOING STANDUP comedy in high school. I struggled to figure out what type of comic I was. A Steven Wright type telling weird, surreal, short, and cleverly worded jokes? Or a Seinfeldian doing observational humor? Dennis Miller rants? When I was 15, Daryl Lennox, a much older comic, told me that I was a comedian, but not a great one. He told me that I was pretty good, but I'd be way better if I talked about the 15-year-old stuff I was actually going through, the stuff adult comics couldn't. Soon after, I got dumped by a girl. I wrote a joke about it, and started performing it.

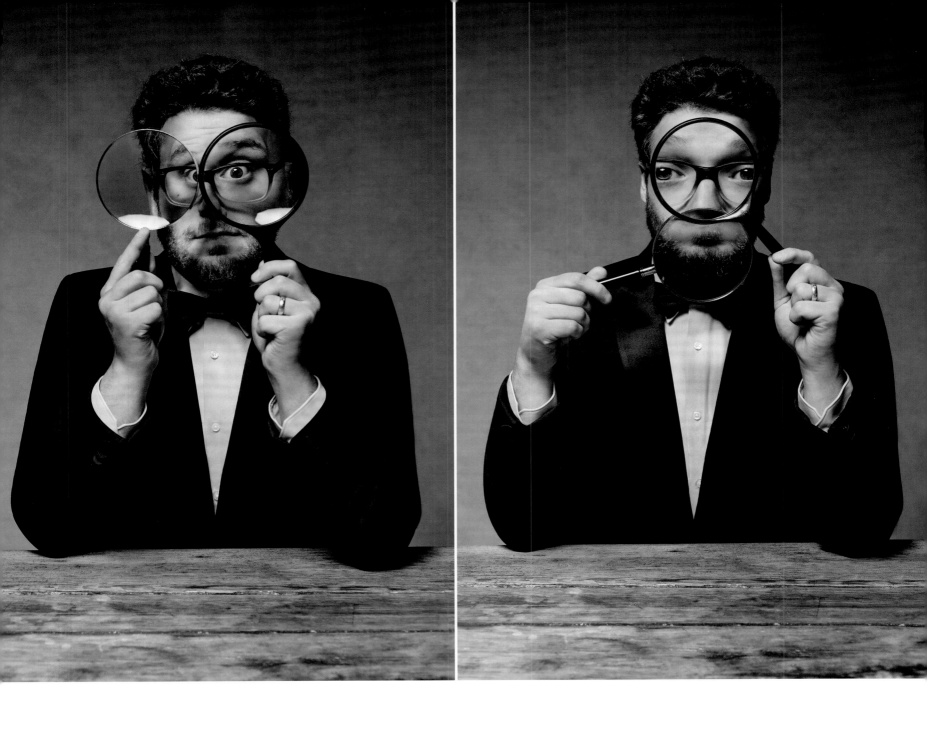

It was my funniest routine. I realized that tapping into my life—what I was thinking about,
what was bothering and stressing me out—was the most fertile ground for comedy. And I enjoyed
doing it because I was able to talk trash to hundreds of people across Vancouver about my
awful ex-girlfriend. The joke was about liking this girl forever and when she said she'd go out with me,
I was so psyched. Then, three days later, with no warning she dumped me. It was brutal. My joke
was about asking her for one last kiss, so I could leave her with something special. I did. Strep throat.
That was the big punch line. Picture a 15-year-old saying it. It was funny.

SETH ROGEN

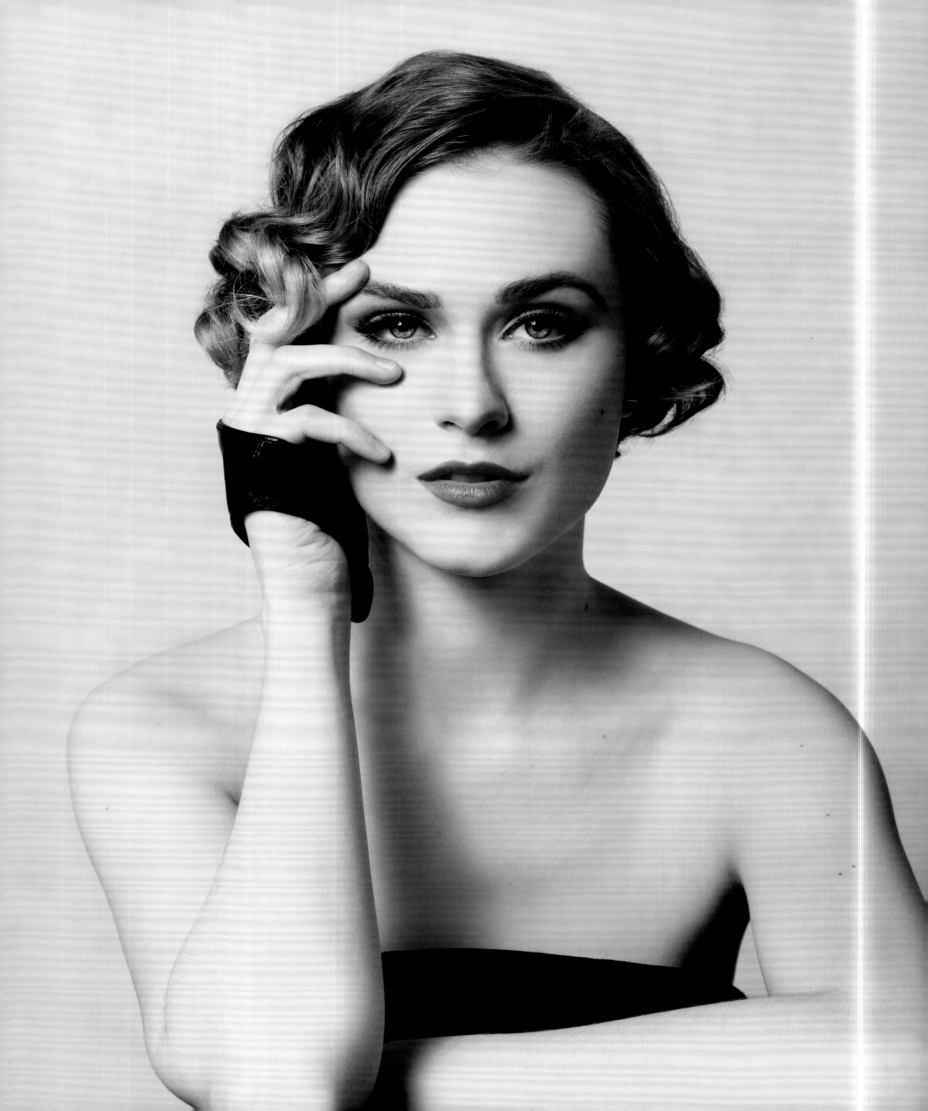

There was a point when I was really down, uninspired, and in a bad place. I didn't want to be an actor anymore. I was done because I thought that acting didn't mean anything—that I wasn't making a difference in people's lives. I ended up seeing a therapist to help get me out of that rut. One day she amazed me and said, "I became a therapist because I saw *Thirteen*, and that made me want to help people." It was just the craziest aha moment because if I hadn't done that movie, she wouldn't have been sitting across from me. The coincidence blew my mind, and that fateful moment changed my whole perspective. It was a wake-up call that what you do matters. When I create things and put them out into the world, even if I can't always see the results, things happen unexpectedly.

Some things die, ART *lives on and continues to inspire.*

Up until I got *Spring Awakening* on Broadway, I always just wanted to get a job, any job. When I did that show, I learned the importance of really believing in the project.

THAT IS THE DIFFERENCE BETWEEN AN ACTOR AND AN ARTIST.

An artist is someone who can really get behind what they are performing because they believe in the message of what the project is about. I remember seeing how people were affected by the show. People with kids would be by the stage door crying hysterically, invested in the show's message and in Melchior, the character I played. I had a quote that I looked at every day before I went onstage: "Don't let the world define you." That was my mantra. When I left the show, the quote became a part of me as a person and as an artist. *Spring Awakening* transformed me from an actor into an artist. It changed me. I now set the bar very high creatively and choose projects that I know I really believe in with all my heart.

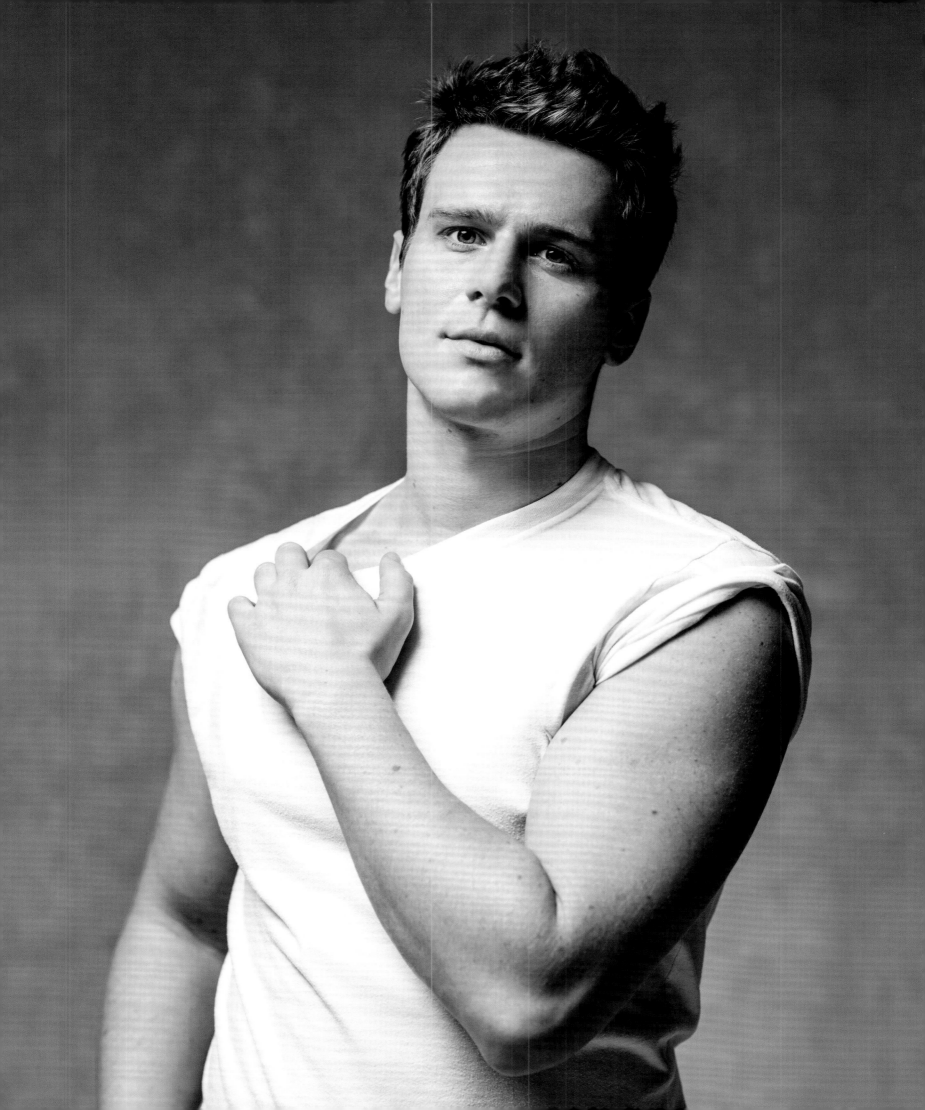

My mother was adamant about having photographs around the house when I was a kid, so I'm always aware of trying to capture moments. She made sure that no matter what birthday it was, my six siblings and I would get dressed up and have our pictures taken. My mom created individual albums for her children, each one with our name on it, and it included every significant moment from our births on. Those photographs made us feel important, really important. But until a few years ago, I had never seen a picture of my parents before they came to this country from Nigeria. Seeing those photos of my young parents blew my mind. It was the beginning of my seeing them as actual human beings who were once like me—teenagers who had dreams and goals of their own. I still like taking covert pictures and keeping video diaries. There's just so much going on inside of me that sometimes I'm too tired to write, so I just put the camera on.

We traveled all over the world because
my dad was an officer in the Navy.

We lived like gypsies, and I could reinvent myself wherever we went.

I could pass myself off as a different person, and feel the different ways I was treated depending on how I presented myself.

Wherever we went, my sister Leslie organized what we called "front porch theater." We'd put up curtains on the front porch, make popcorn, sell tickets, and do plays for the neighborhood. I called it "spam acting," because it was far beyond ham acting. We did a production of *The Princess and the Pea* and I had to bring a cake onstage. I decided to show how heavy it was, so I got up on a chair and the audience laughed. It was a very direct correlation for me between doing something onstage, pleasing people, and bringing laughter. I realized at that moment that there is power in even the smallest movement you do or the largest moment you create, and there's a freedom in that expression that has a direct effect on the audience.

I saw my first opera when we lived in Greece. I didn't understand the language, but I did understand that this larger-than-life woman was experiencing larger-than-life emotions.

We lived in a little house on a knoll that stood by itself when we were in Japan. We had turtles, goldfish, and 16 love birds. There was a rope swing in the backyard, and a bamboo forest that we weren't allowed to go into because there were caves where human bones had been found. When I was nine, I went to Bon Odori, the Japanese harvest festival, where people danced and built paper temples in the middle of fields and parking lots. I got separated from my family and found myself surrounded by hundreds of strangers doing a rhythmic dance around an interior of a lit, paper-laminated temple, singing a song I still remember to this day. It was a repetitive song that went around and around. It wasn't quite a meditation, but it was the first time I remember experiencing freedom. I wasn't with anybody I knew. I was dancing in a field in the middle of Japan with the stars overhead, and it was a fabulous feeling of being a part of something expressing tradition and joy through music and dance. I remember thinking it was the same feeling as when I did front porch theater.

hen I was growing up, my dad worked at KCAL Channel 9. He'd take me on tours of Paramount Studios, where incredible movies and television shows like *Jaws* and *Cheers* were filmed. It was a larger-than-life experience. I was a ballerina when I was younger, and started acting classes when I got bored. I loved the psychology behind acting. I loved being able to dive into a human being and understand who they are. My first acting teacher taught me an important lesson: acting is the study of human behavior. That's when I had a light-bulb moment when I thought, "Okay, I can do this the rest of my life because acting will fascinate me forever." Later, things came full circle when I worked on *Felicity* and gave my Dad a tour of my stage. I felt like I had accomplished something, and I could give something back to him.

After saving my allowance for ten years,
I flew to Paris when I was 15 years old. When I visited
the Musée Rodin, I was profoundly inspired
by the story and the pain of

CAMILLE CLAUDEL.

Her diminutive sculptures—much smaller
in stature to Rodin's—led me to become an artist.
They are so small, yet so powerful and so heartbreaking.
They embody the fiery emotion that
reflect Claudel's tortured love affair with Rodin.
They are beautiful.

ROSE McGOWAN

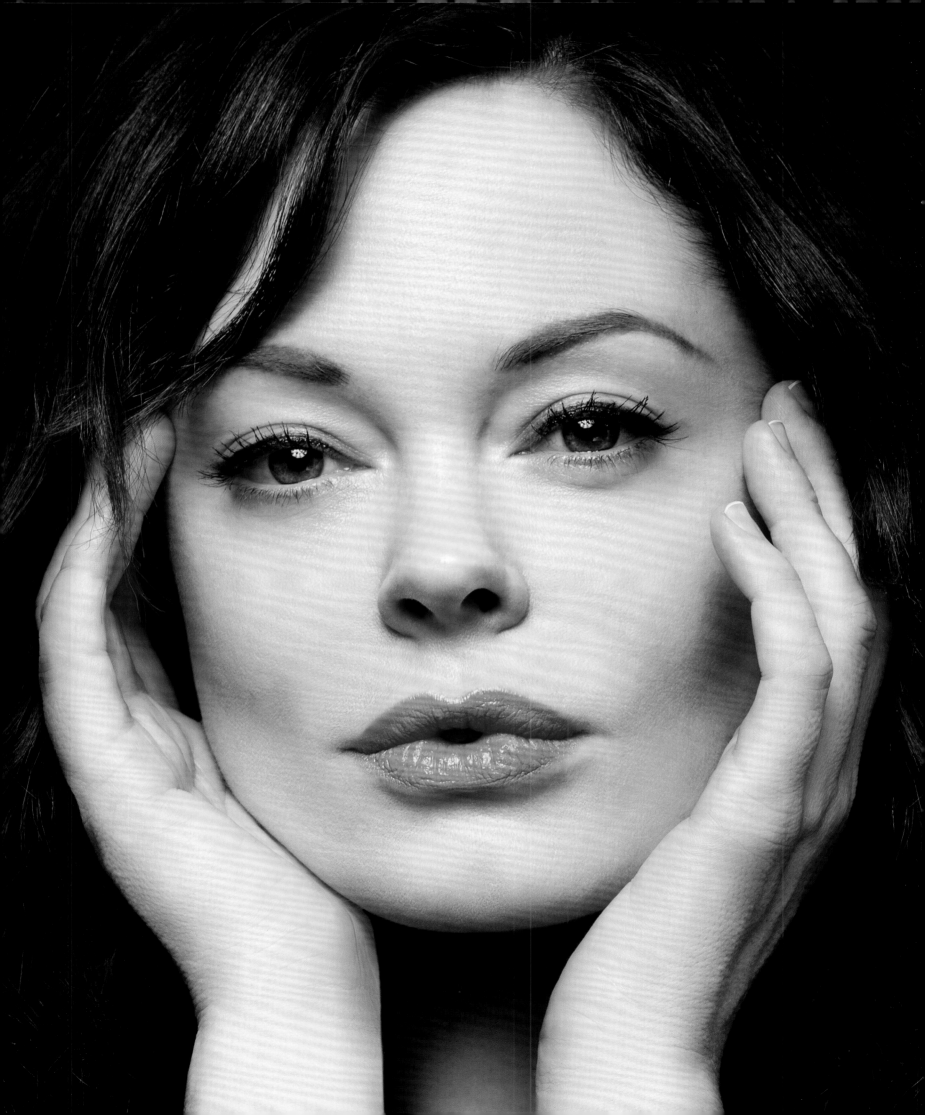

When I was in the fourth grade at Half Hollow Hill Elementary School in Dix Hills, Long Island, we performed the play *George Washington Slept Here*. Being of southern Italian descent and having strong dark features, I was cast as Sam, a 70-year-old black butler who had wisdom and heart. He was the most interesting and challenging character a nine-year-old could take on. After the performance, while walking with my parents to the car, my teacher Mrs. Alexander said, "Your son has a natural talent and he should be encouraged to pursue the arts." My fate was sealed.

When I was growing up, the arts were an integral part of education and child development. Music, drama, and the fine arts were all part of the school's curriculum and after-school activities. We were all given a recorder in first grade and were taught to play a few tunes. It exposed me to music and a way of listening that has helped everything since. Who knows what path I would have taken had I not grown up when I did?

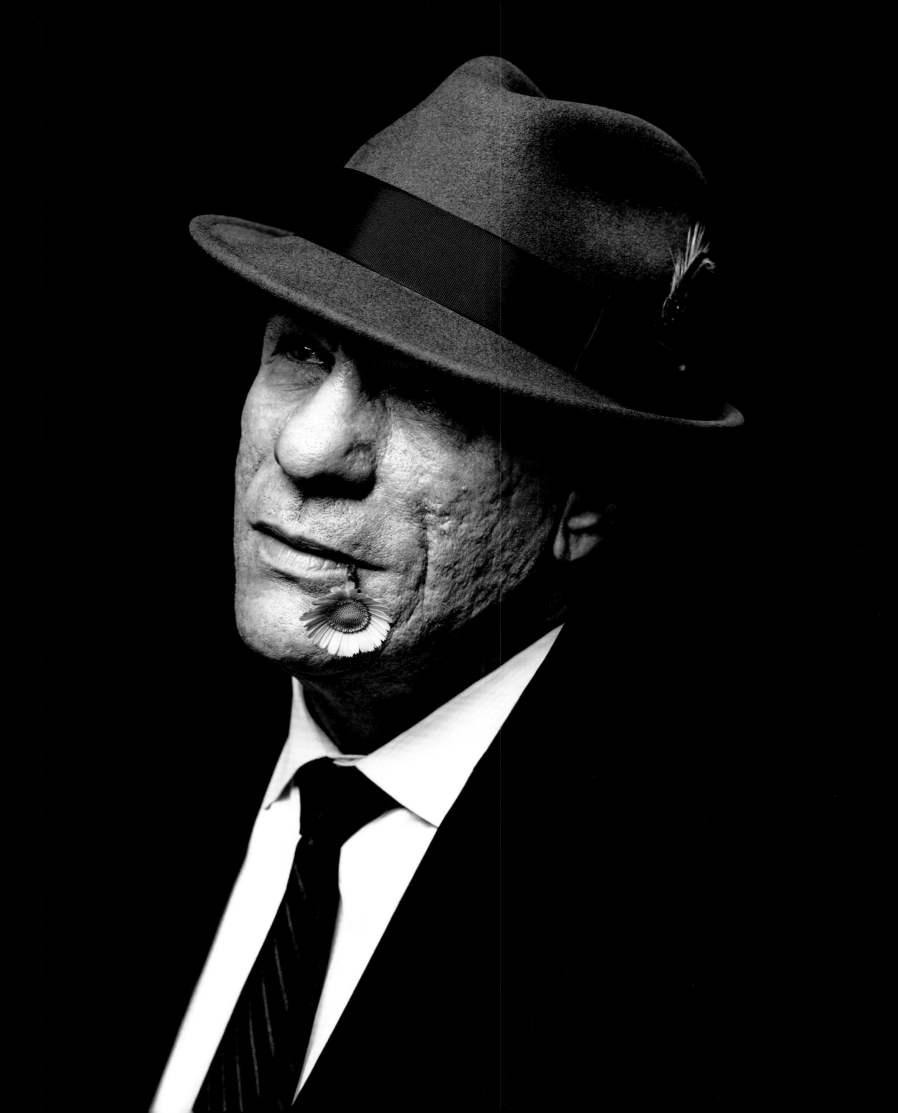

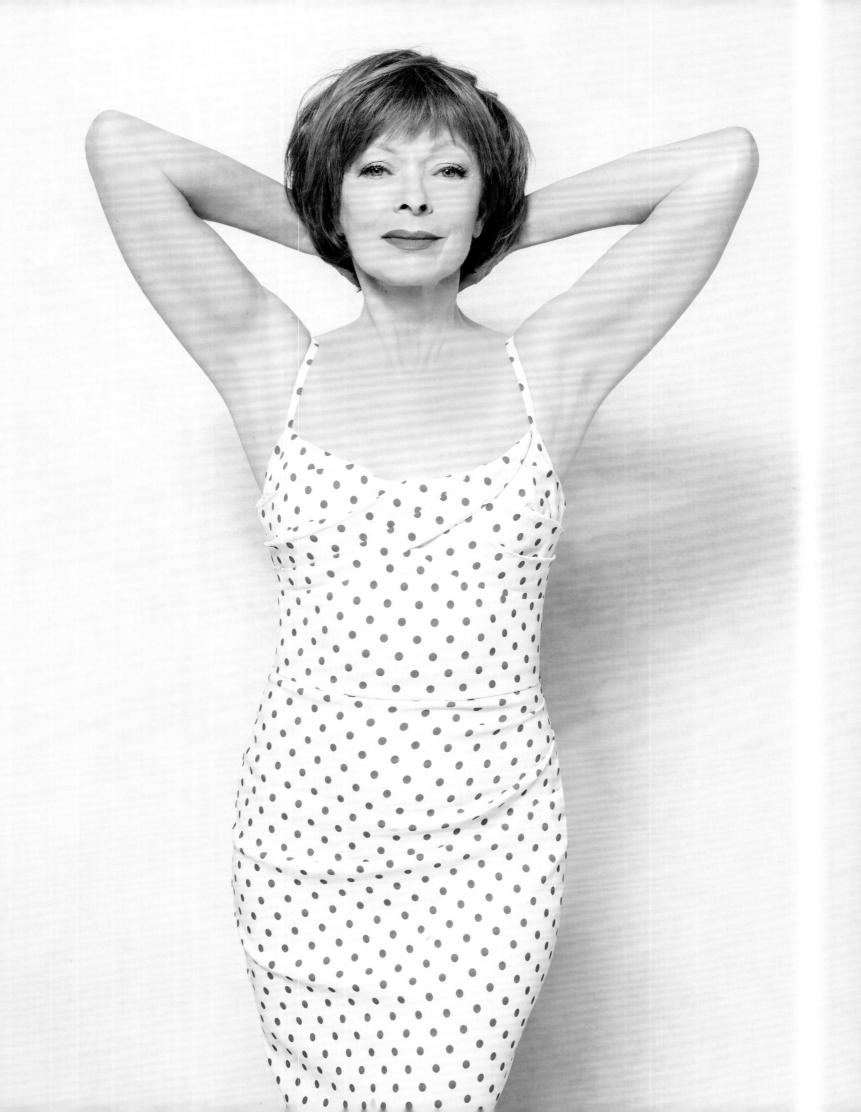

I was 20 years old and living in Orange, Texas. After a community theater performance of Tennessee Williams', *Summer and Smoke*, I was at the after-party and a New York actor, John Holland, said, "You have talent. You can get out of this small town and become a professional actress."
I'd never heard that kind of encouragement before.
I completed productions of *A Man for All Seasons* and *Mame*, quit my job at Firestone, divorced my husband, ate my last chicken-fried steak, and got on a Greyhound bus. I rode all night in the rain to the Barter Theatre in Virginia, where I apprenticed for a season. I made the choice to live my dream.

The moment my child

was placed in my arms, my
sense of purpose as a mother
was revealed to me. It was
transformational and divine.
I found something
that gave me purpose
outside of myself, and
I discovered
what I am
made of.

ELIZABETH BERKLEY

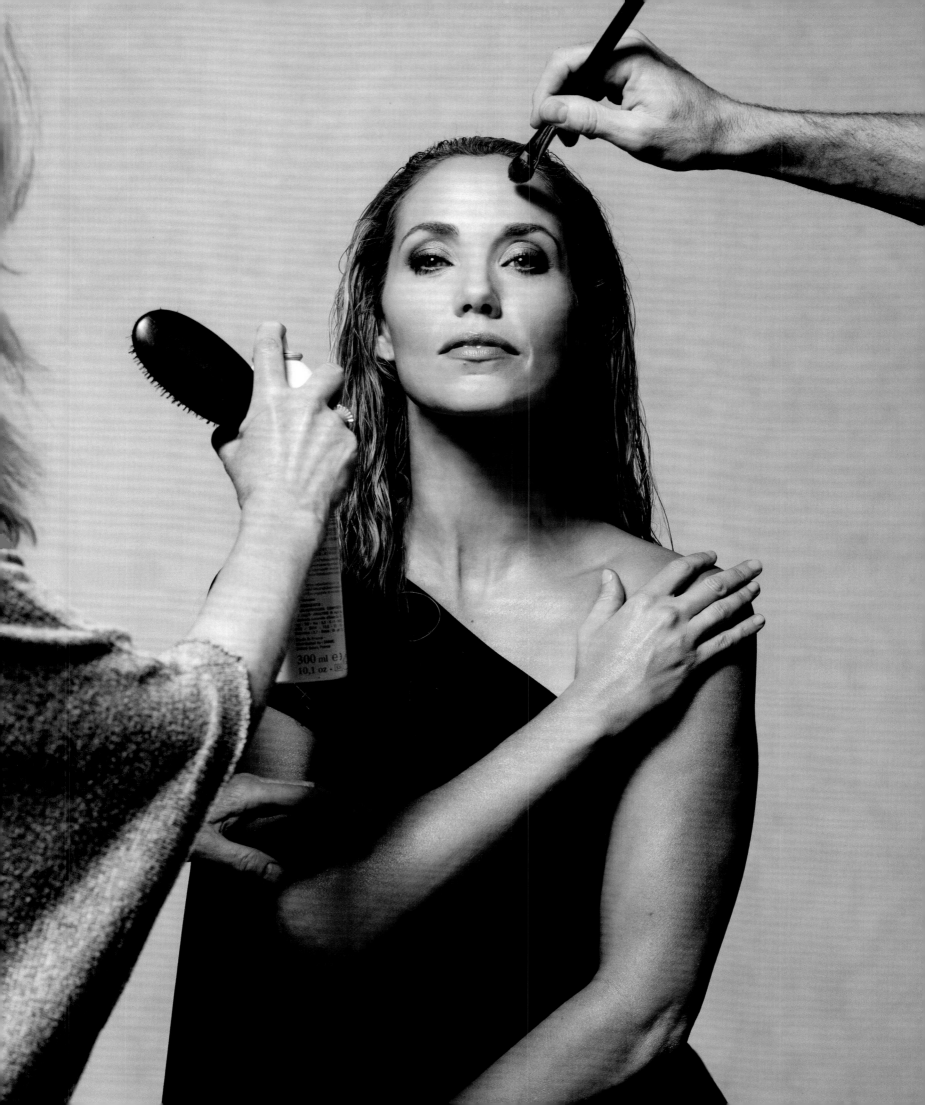

My father took me to see

Terms of Endearment. I was eight and way too young to handle it. I started crying when the kids were saying good-bye to their mother on her deathbed. At the same time, something clicked for me. Sitting in that theater, looking up at the giant movie screen, I was one of those children saying good-bye to my mother on her deathbed. I was as in the moment as the actors were on the screen. For the first time in my life, I felt the power of great art. From that moment on, I never wanted to do anything other than make movies.

ZACH BRAFF

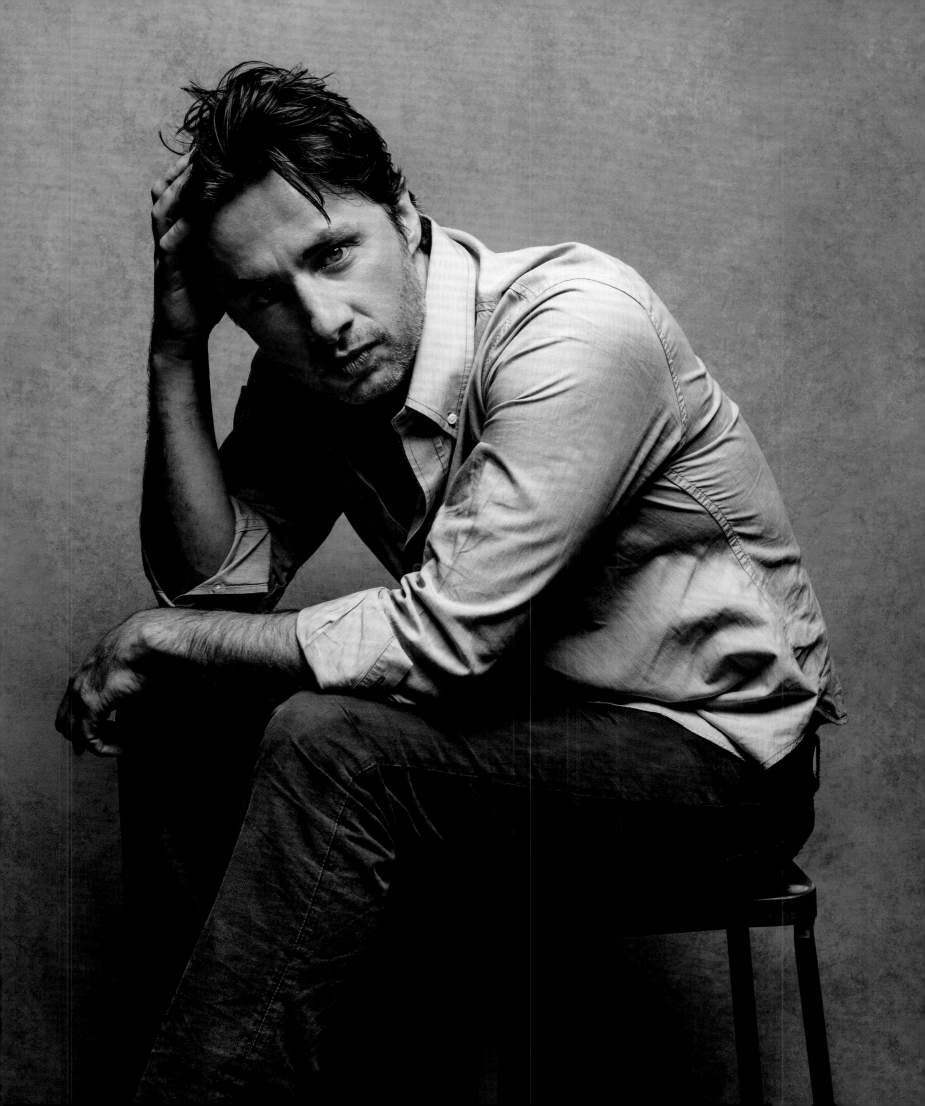

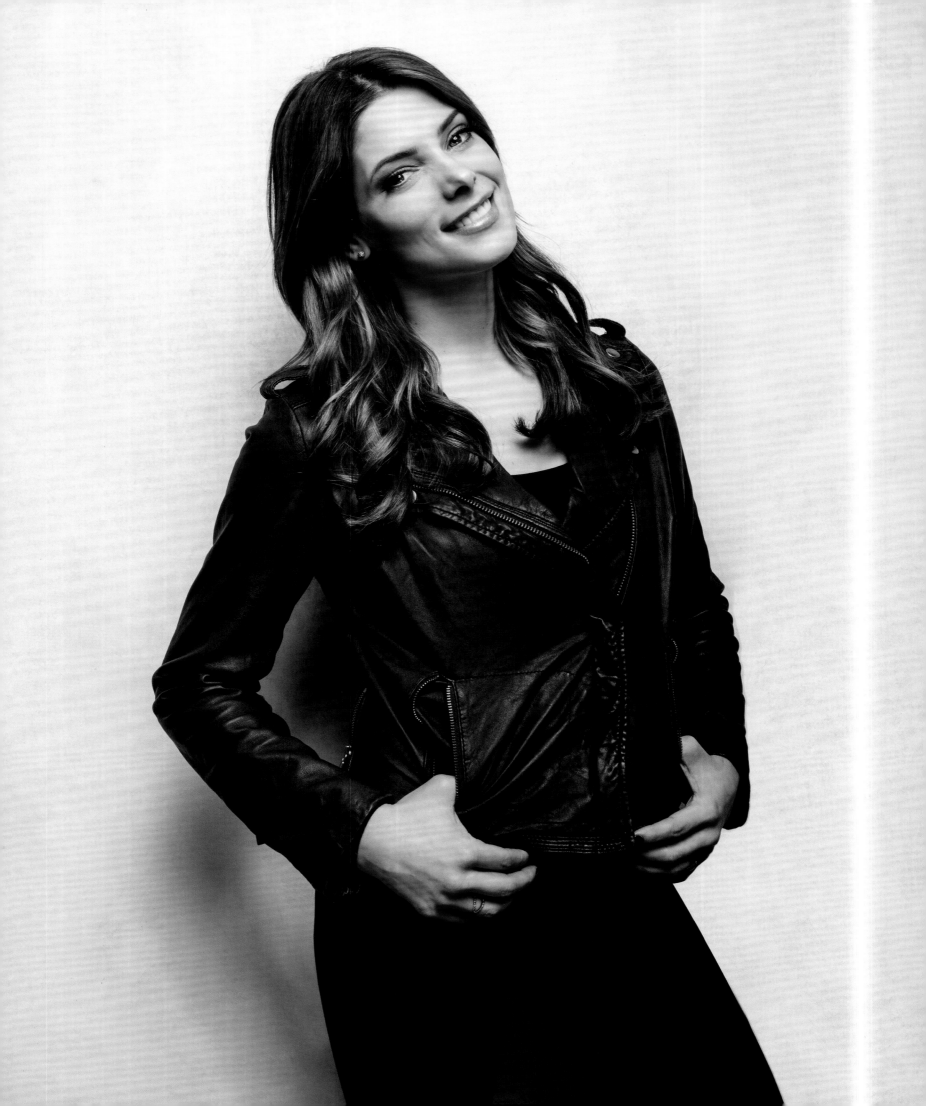

FEW YEARS AGO, I ATTENDED THE "NO MORE"
CAMPAIGN IN WASHINGTON, D.C., AND GOT A CHANCE
TO SPEAK ABOUT, AND HEAR FROM, SURVIVORS
OF DOMESTIC ABUSE. IT REMINDED ME THAT ONE
OF THE GREATEST GIFTS OF MY JOB IS THE
ABILITY TO BE A VOICE FOR THESE WOMEN. NO MATTER
WHAT UPS AND DOWNS I'VE FACED, THIS
MOMENT MADE IT ALL WORTHWHILE, AND INSPIRED
ME TO CONTINUE PUSHING FORWARD.

ASHLEY GREENE

My life changed when my daughter was born.
I was 26, and had never really understood
how human beings were connected.
I went across the street from the hospital to get
a drink and think. I thought about how we're really
all connected. We go about our life, watching
stuff on the news, hearing things on the radio, and
we think "as long as this happens over
there, it's okay." Until it happens at your doorstep.
How do we have compassion for each other?
How do we understand? How do we look out for
one another? Give up your bus seat for an
elderly woman. Go to the aid of someone in distress.
Every day heroes run into burning buildings
to save strangers.

WE HAVE AN AMAZING CAPABILITY TO CONNECT.

And the first time I truly understood was
when my oldest daughter was born.

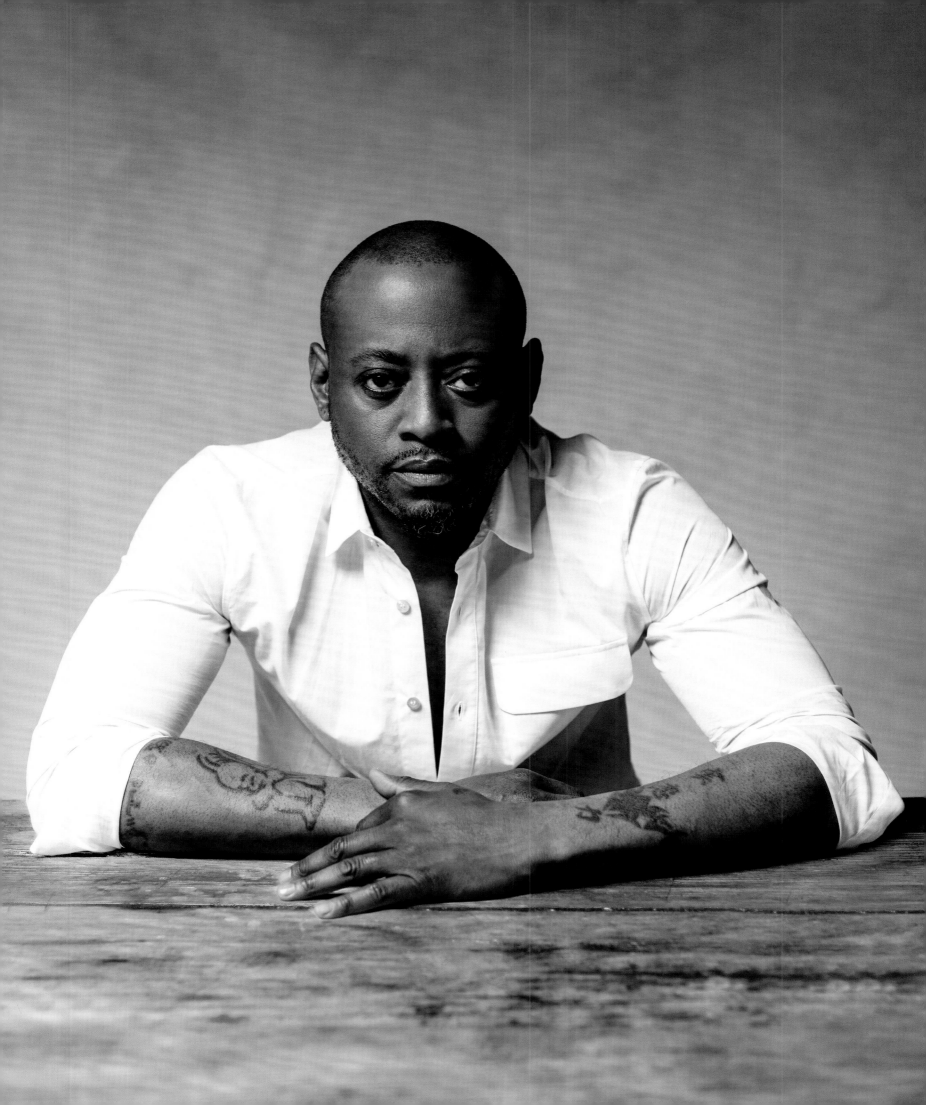

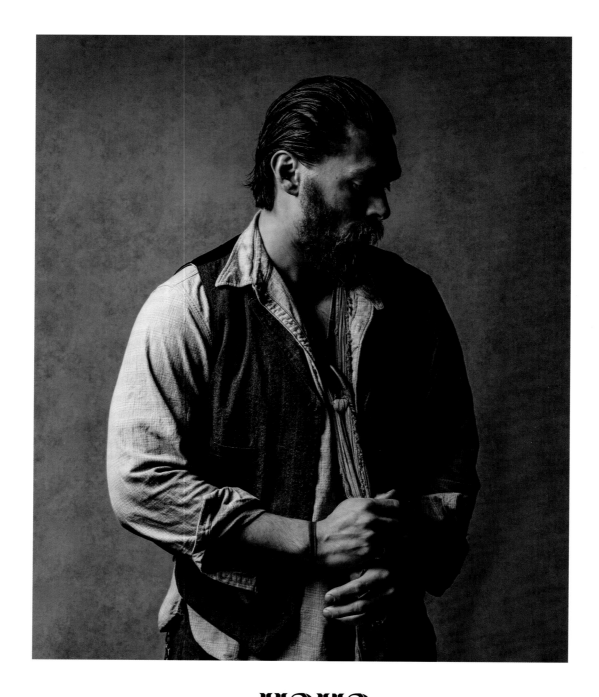

I'm half Hawaiian and the **HAKA** is a very sacred thing,
something your family teaches you. I often go back to
my roots and perform this traditional dance to channel my inner warrior.
It helps me stay connected and helps me find my center.

JASON MOMOA

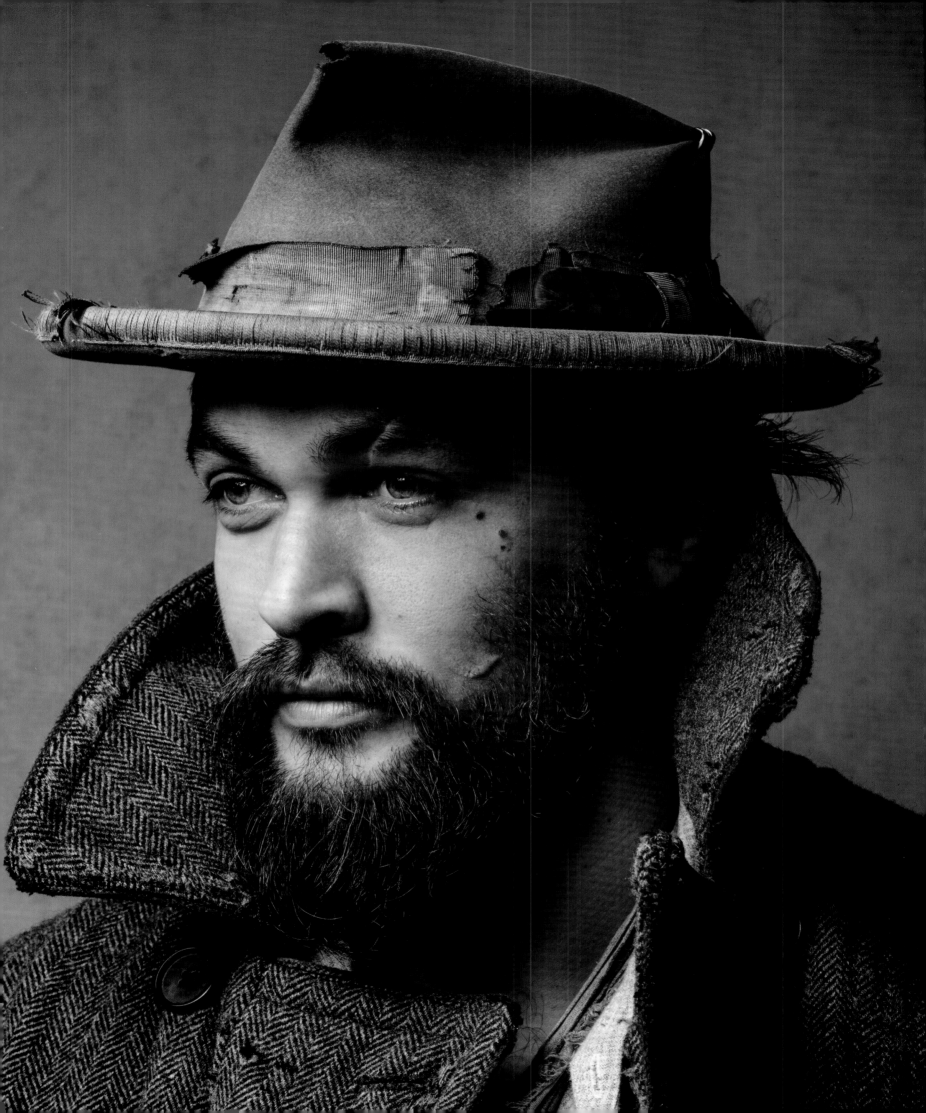

It was

MIDNIGHT

ON A FRIDAY. I WAS WORKING AT A BANK, SITTING IN A GRAY CUBICLE ENTERING NUMBERS INTO A SPREADSHEET. I WAS STRUCK BY MY MORTALITY. I WAS 22 AND SUDDENLY, ACUTELY AWARE THAT I WAS GOING TO DIE, AND MAYBE IT WASN'T AS FAR OFF AS IT HAD PREVIOUSLY SEEMED. I ASKED MYSELF, "WHAT MUST YOU DO BEFORE YOU DIE? TURN MONEY INTO MORE MONEY?" I AM STILL TRYING TO ANSWER THAT QUESTION.

My mother instilled in me that anything is possible, I'm capable of anything, and I should dream and dream big. When I was ten, my mom and I were homeless for two years. I had a Harvard sweatshirt that I'd wear every day and, because I couldn't wash it, I'd bathe in Polo cologne. We lived in an abandoned factory in downtown Minneapolis. It had cracks in the ceiling and gaping holes in the walls. I remember lying in a sleeping bag next to my mom in the freezing cold one night and making a connection with a star. It was my first spiritual experience. I finally felt connected to the world. I had an overwhelming sense of oneness and relief from the energy that washed over me. It was a huge turning point in my life. I felt like I wasn't alone, and that I mattered. At that moment, I knew that life was going to be okay.

I STILL LOOK UP TO THE STARS

to remind myself that I can still take risks, explore my fears, and challenge myself.

I was 19, a high school dropout and had seven dollars to my name. Should I go eat with this money? Or go pay back the five dollars that I borrowed from my friend who's also hungry or put gas in my car? That's when I knew. I had no choice but to work. There's nothing like having only seven dollars in your bank account to make you focus and try to be better at what you do. I had to make the decision that I was not going to be sidetracked. I would bang down doors and be hungry, then wait on tables. I would not be complacent.

WHEN YOU'RE ACTUALLY TRULY HUNGRY, PHYSICALLY HUNGRY, AND YOU HAVE NO MEANS TO SUSTAIN YOURSELF, YOU HAVE NO CHOICE BUT TO TRY TO FIND YOUR INSPIRATION.

Y PARENTS SEPARATED WHEN I WAS VERY young. There was a time when I lived part-time in a tepee with my mom in Paradise, California, and part-time with my dad, who had a house with a swimming pool and tennis court. I think the eclectic nature of my childhood led me to acting. After a brief stint modeling in New York City, I realized that I just didn't fit into that life, so I went back to Los Angeles, where my aunt, Carol Merrill (who was on *Let's Make a Deal*), turned me onto acting classes. I was a straight-A student, so my family never thought I would go into acting, but it turned out that I loved it more than anything else. I fought really hard to get my first Broadway role of Maggie in Arthur Miller's *After the Fall*. I knew a lot about the way that film and television worked, but I didn't really know about Broadway. I didn't know how the stage worked or that a Thursday night audience was different than a Wednesday matinee audience. I discovered it was incredibly liberating to not pretend to know something when I didn't. By approaching my stage debut that way, I was able to go to a deeper emotional place than I'd ever gone to before as an actor. It completely changed the trajectory of my career. The roles that I've performed onstage have impacted my subsequent choices in film and television.

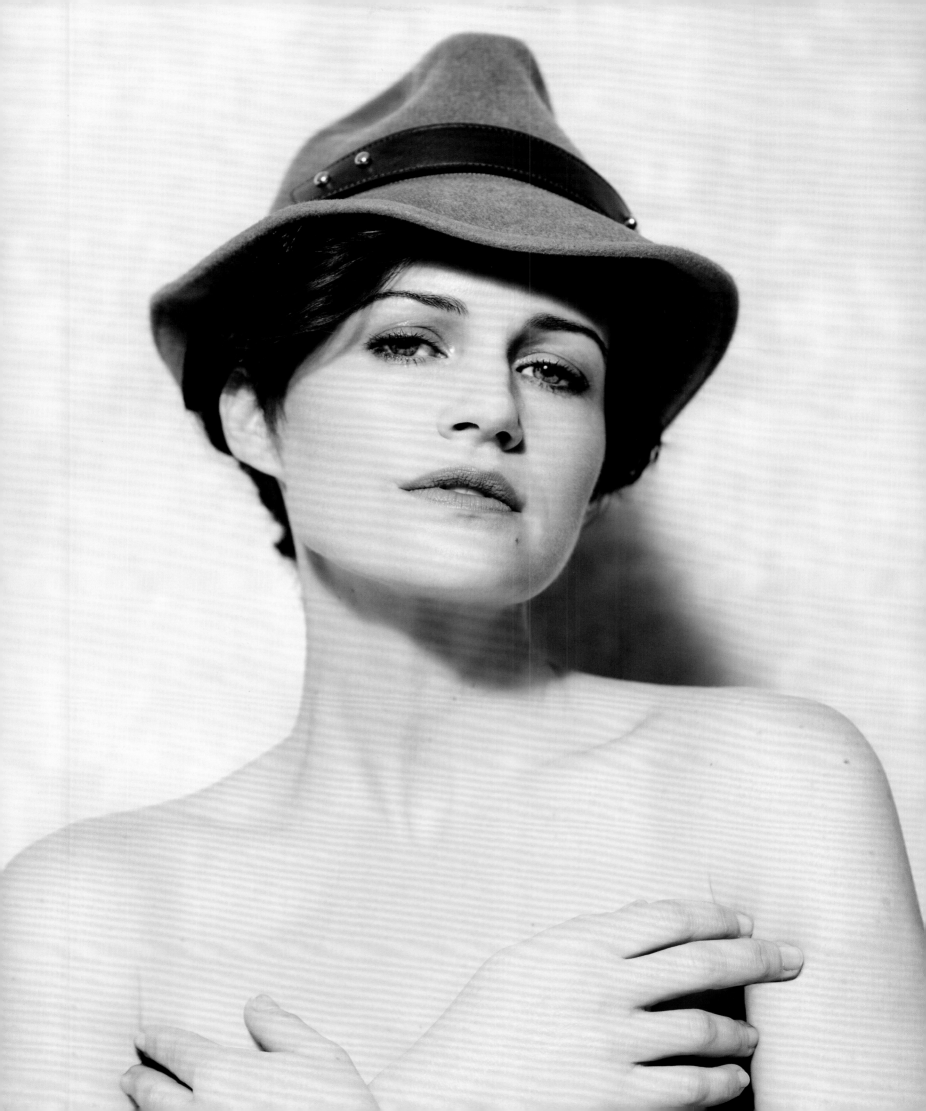

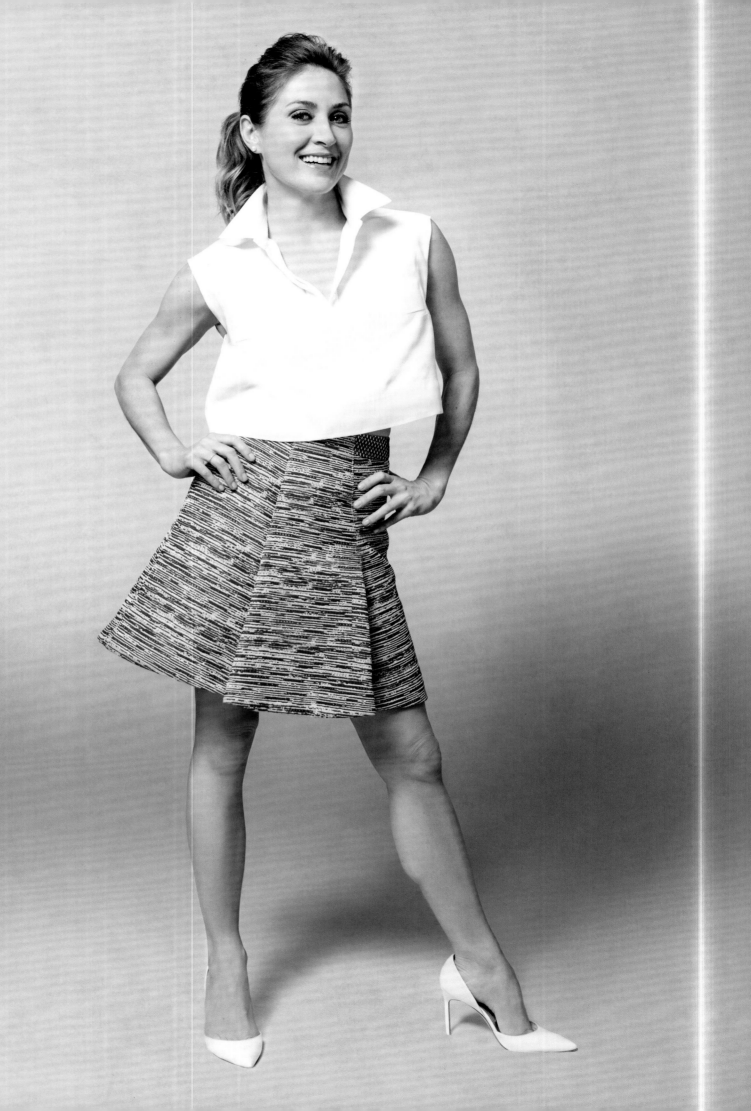

I GAVE BIRTH

to my daughter and lost my father to cancer within
five months. You go through pregnancy and you give life,
and then all of the sudden this man who gave you
life is gone. He wasn't always there the way I had hoped,
but he was there the way he knew how to be.
I was grateful that by the time he died, I was able
to work that stuff out. Being loved is an enormous thing.
I was loved, but not necessarily understood.

MY SENSES
WERE OPENED
TO LIFE,
DEATH, AND
THE STUFF THAT
HAPPENS
IN BETWEEN.

I lived in stinky, smelly Jakarta,
Indonesia for a year when I made my
first movie. It was the worst movie,
but making it was the best experience
ever. Jakarta is a city that has one
foot in the 20th century, and the other in
the 19th. It is primitive, yet in many
respects, charming and beautiful, too.
All the canals are completely
polluted, and there was a butter
sculpture outside my hotel that had been
there for 20 years. The Muslim
call to prayer every day is haunting.
**That experience opened
me up to the idea that when you
make relationships with
people in other parts of the world,
anywhere can be your home.**

CHRIS NOTH

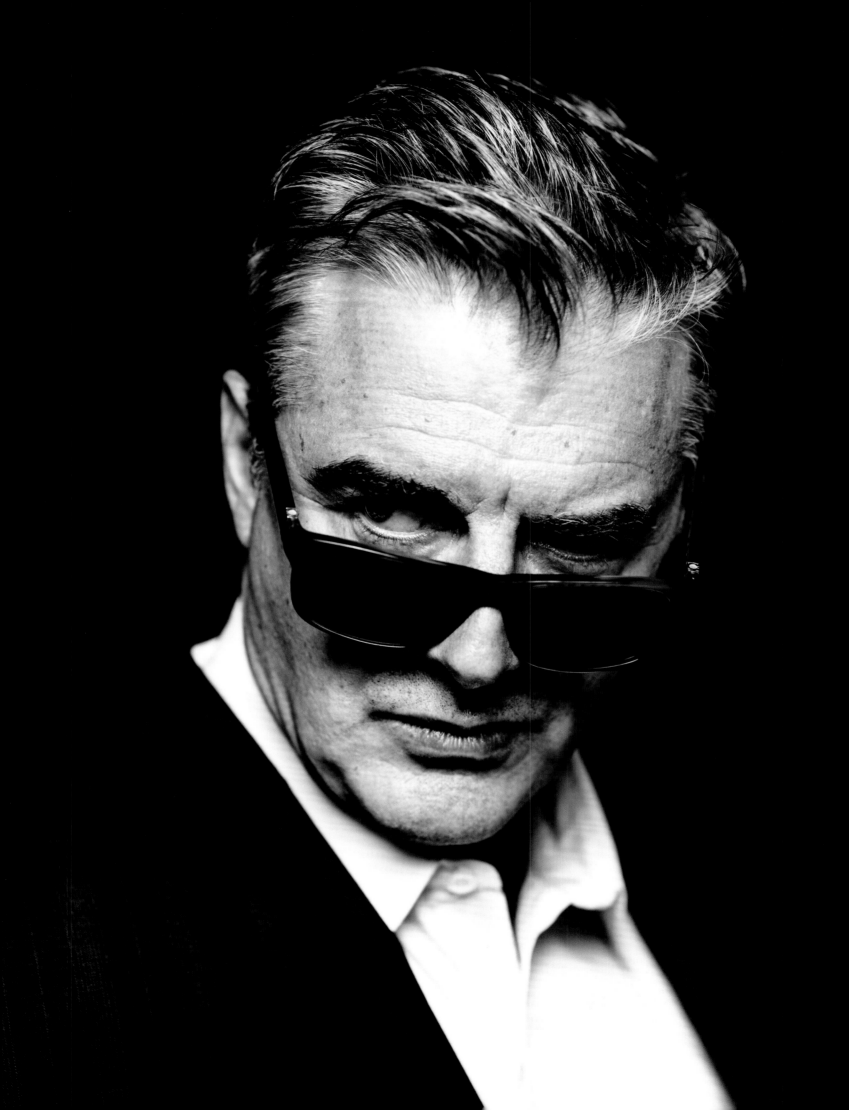

I first saw
Eric Bogosian's film,

Sex, Drugs, Rock & Roll,

when I was in high school. I remember being amazed that an actor could write his or her own material and then perform it fluidly and clearly without the help of sets, props, costumes, or even other actors. Just the raw expressiveness of well-structured work in an empty space. It was then that the power and limitlessness of theater opened up to me. Just with the tilt of his head, Bogosian could actually convey the expression of the "other person" on stage, even though there was no one there. Bogosian was cool. And smart. And irreverent. Hell, he was raunchy.

One day during a college semester in Oxford, I opened the London *Telegraph* and saw an advertisement for Eric Bogosian's *Pounding Nails in the Floor with My Forehead*, as performed by the author. My head almost exploded. I hopped the train to London and found my way to the Almeida Theater. The lights dimmed and then came up on Bogosian on an empty stage. What followed was the most brilliant, most nuanced, and most profane performance I had ever seen. I was transported to every space he indicated, and chose sides in every conversation he conveyed.

I waited for him outside his dressing room. All these years later, Eric and I now have the same manager. Through that association we have gotten to know each other a bit, and he even invited me to a poker game he used to host. It was over a hand of Texas Hold'em that I got to remind him of that skinny kid in the Buddy Holly glasses that waited for him outside of his dressing room. I still haven't managed to express to him how much his work changed the way I saw acting and also gave me the courage to pursue this profession. I hope this suffices.

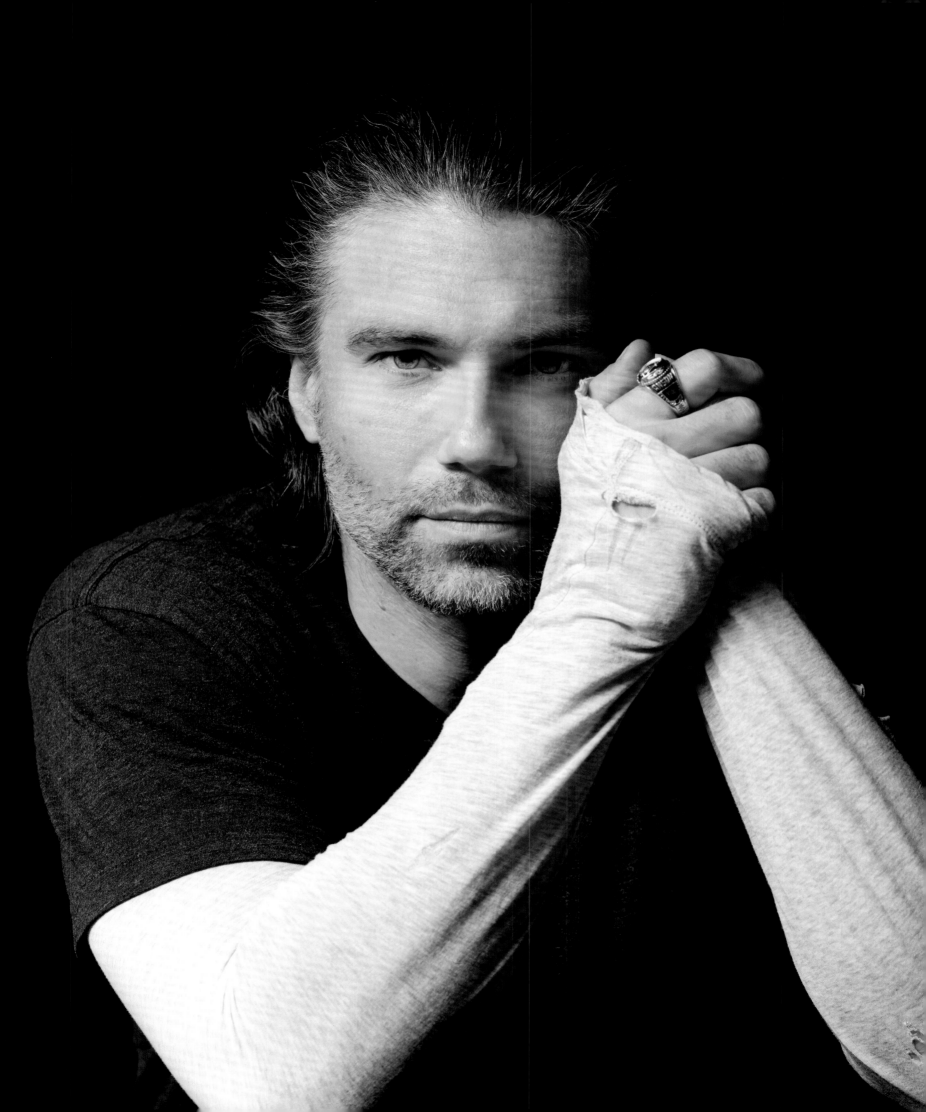

When I was ten years old, my parents took me to see the movie, *Scanners*. You would never take your kid to see a movie like that today, but back in 1980, we didn't wear seat belts, kids never wore helmets, and parents didn't think twice about taking their children to completely whacked-out movies! In the film, people have the ability to control others with their minds, and in one scene, Michael Ironside actually makes another man's head explode like a watermelon. I was in awe. That was the moment that I knew I had to make movies.

Right after I moved to Los Angeles, I went to see a show at the Groundlings Theater. I was amazed. The actors were the funniest, smartest, silliest people I had ever seen. I was so inspired that I sat in the theater thinking, *I want to do that, I want to be them.* Up until then, the acting classes I took were very serious. Everybody was in a lot of pain, and there was a lot of crying onstage. And then, when class ended, they were still really serious and tortured souls. I sometimes felt like I didn't really belong there because I liked life. So even though I had zero money, I took a Groundlings class, and it changed my life. I would leave class laughing, and would laugh about what people did in my class for days after. I'm still quoting those lines. Seeing comedy made me feel like,

Oh, this is what I've been searching for.

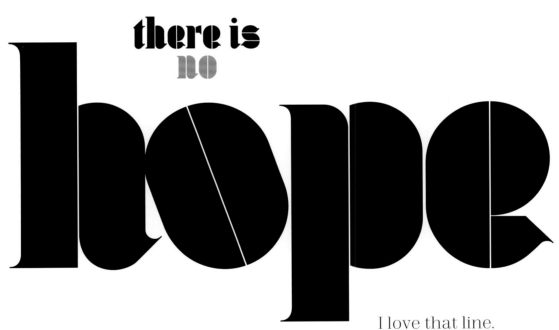

there is no hope

I love that line.
Gina Rowlands said it in John Cassavetes'
movie, *Opening Night*.
When there is no hope—when life
becomes too hard, I'm creatively inspired
because I feel that
I am still alive.

RINKO KIKUCHI

One Christmas, when I was 16, I went to Dublin on a trip with my theater group. We were performing *The Tempest*, and were quite the traveling circus. We all helped with the costumes, the music, everything. For me, it was a coming of age. Dublin is such a romantic, beautiful, old city. We drank illicit Guinness and wore scarves that were wrapped too many times around our precocious necks. It was the first time I got a sense of how much fun it could be if I managed to con my way into the world of acting.

Just eternal play, collaboration, and romance.

I was in love with a girl who was there, and went to see *Playboy of the Western World*. That trip was what got me hooked. I came home and told my parents, "I want to go to drama school." My dad said, "Why would you want to be an actor? You can't dance and you're too tall to be in the chorus line." They pressured me not to go to drama school and to go and get a college degree instead. I went to Cambridge, although it turns out I'm lucky enough to be acting, so maybe it wasn't required. My parents are supportive now, but I still don't know how that Charleston two-step is going to turn out. I hope my top hat doesn't fall off in front of the Queen.

I think we gain perspective from

LIFE AND DEATH.

I've gained the most perspective in life through the life
of my son, Brody. When he had his first breath of life and was placed
onto my tummy, it was like his heart was on top of my heart and,
suddenly, the entire universe opened up to me. I gained the clearest
perspective, and I knew what my purpose was. Turns out it was
not to be a creative artist and performer. It was to breathe life into this
little being, to watch him grow, and to be a mama in every sense
of the word. It was the craziest, most intense, most unexpected feeling
of my entire life. I had no idea I would feel that way. Just feeling
his tiny tummy breathing in and out on top of my own, seeing him move
and squirm and open his eyes for the first time and
locking on to my own eyes—it was the most beautiful thing
I'd ever experienced.

TERESA PALMER

When I was a kid, I took the train from Trenton, New Jersey, to New York City once a month on a Saturday. I would go to the half-price ticket booth and get a ticket for a Broadway matinee. After the show, I would stop at the Samuel French Bookstore, then to Sam Goody to look at records, and on to Nathan's for two hot dogs. Then I'd buy a ticket for another Broadway show that night. When I was about 14 years old, I saw a matinee of *Lenny* with Cliff Gorman, about the life of Lenny Bruce. That day I was so taken by this show that I went and I saw it again that night. The images were profound—when Lenny Bruce died, there was a huge tableau of Mount Rushmore that took up the whole stage. Then the scenery parted, and Lenny Bruce was in a corner, prone over the toilet, dead from overdosing. It just blew me away. When my dad picked me up at the Trenton train station that night, I asked him if Lenny Bruce was a real person. I didn't know if he had been made up, like Robin Hood. Was he a

MYTHICAL
CREATURE

or a fictional creature? My somewhat conservative dad did not love that I had seen the play about Lenny Bruce, and wasn't happy about me being exposed to his humor. But it was too late. That play really changed my life and made me want to become an actor. By the way, the actress playing Lenny's wife was naked on stage. Now that really had an effect on me.

It was the First Grade
Christmas Pageant. Six of us were chosen
to play each of the letters in

C-A-N-D-L-E

I was

"A is for air, so filled with smells of spice,
smells of baking, pudding 'n pie, everything that is nice."
I wore a little candle outfit, and I just loved it.
It was thrilling when the lights came up, and
my heart started pounding. It was kind of like walking
the line between complete terror and ecstasy.
That's something I've been seeking
my whole life.

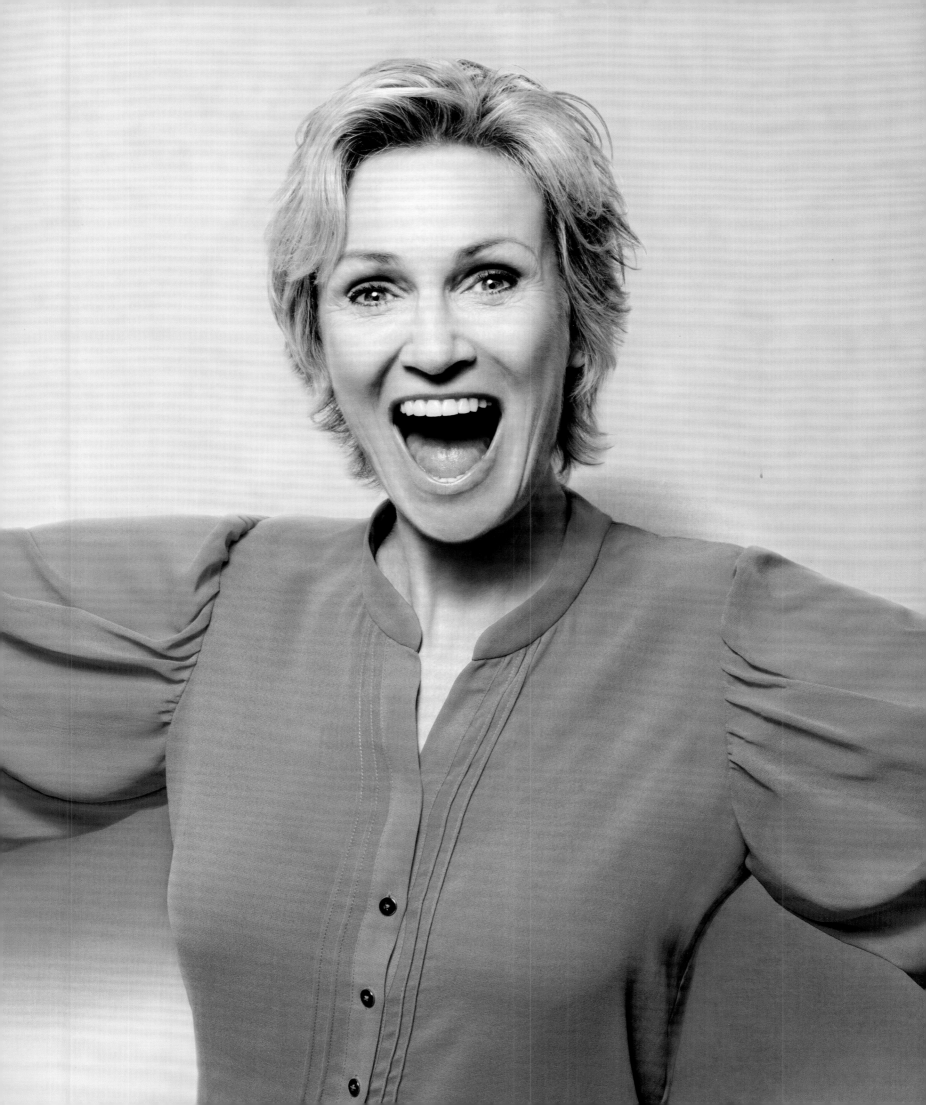

I **worked all my life** until I was 13, when I stopped and decided to be a normal student. I took myself out of the business, didn't even read a script, and stayed in school for three years. But then that love and that passion for acting came back bubbling up. I missed the feeling of happiness I felt when on a set. It was almost like a melancholy kind of feeling. I just wanted to be back on set so badly and that feeling kept creeping and bubbling up in me. When *The Ballad of Jack and Rose* came along everything changed. I started working again at 16.

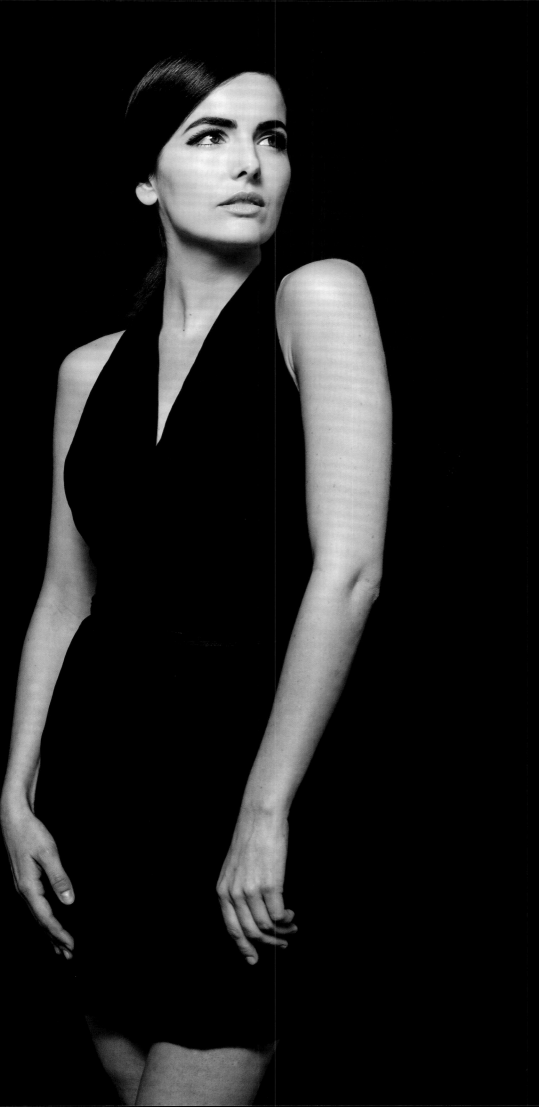

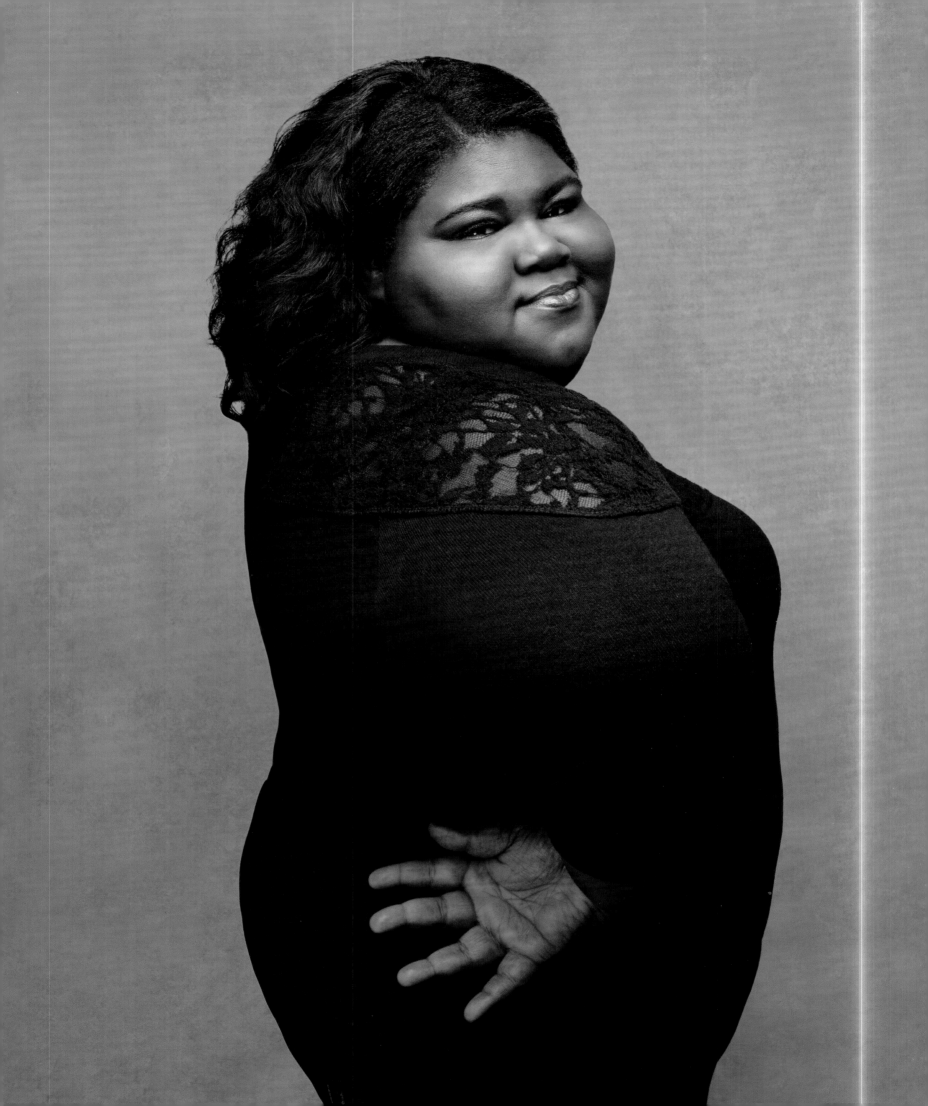

I grew up in Harlem. I took the bus to school in downtown Manhattan. I passed through this neighborhood in the Upper West Side that had really beautiful new buildings. Everything seemed so clean, and a lot better than where I lived. I just knew I wanted to live there. It seems superficial, but I just wanted to live beyond my neighborhood, above what my parents could provide. So every day that I went to school, there was another aha moment of,

THIS IS WHERE I NEED TO BE.

It took work to get there. Now I'm exactly where I want to be. Every now and then I look up at those buildings and I think of the ten-year-old little girl who just wanted to live here in this peaceful space. I am abundantly happy and proud of myself that I made it.

When I was four and five I
performed with the Bread and
Puppet Theater in New York City.
It was early in the 1960s, and
the shows were political fables.
I recall playing the donkey who
carries Mary to the manger, as well
as the angel that toots her horn
and tells Mary, "Be not afraid!"
Peter Schumann would instruct
us to not simply manipulate
the puppet, but to be the puppet.
The audience would come,
we would play, and they would

believe!

My dad was an actor. From time to time, I would go off with him when he did summer stock and hang out at the theaters. For a kid, there is no more magical place in the world than to be backstage at a theater, and in on this big secret that's being played on the audience. There are places to climb. There are beautiful apprentice girls that you can snuggle with. There are places in the rafters that you can peek down from. You can peek out at the audience.

I acted in a few plays when I was a kid. But when I got to high school, I was cast, to my surprise as Malvolio in *Twelfth Night*, which is not a part that I would traditionally be considered for.

After the play, which was performed outdoors in an amphitheater in the woods, a lot of people came up to me and said, "I had no idea it was you—until the second act. I had to figure out which one was you." I realized that I could participate in this deception, which was so fun to pull on an audience, in a different way. Not just as someone who was observing it from backstage, but from the point of view of someone on the stage. I knew, at that thrilling moment, that it was something I could do.

TIM DALY

I was in my father's pickup truck, driving up
Fairfax in Los Angeles. I was six years old and I heard
a song on the radio. It was the first time I ever noticed
hearing music or a song before. "What is that?"
"Oh that's the best band in the world. That's the Beatles."
From that moment on, I couldn't stop listening to
the Beatles. It was an addiction. My father got me each
cassette in sequential order, starting with

HARD
DAY'S
NIGHT.

Then he gave me the next one, and the next one.
I wore each tape out. Music is my inspiration because
it relates to everything.

CHURCH BASEMENT IN 1978.

THE FIRST PERFORMANCE

OF MY FIRST PLAY HAD JUST ENDED,

AND MY GUTS WERE

TREMBLING WITH

A SECRET

I COULDN'T

THEN NAME.

I'D

FALLEN

IN

LOVE.

MICHAEL C. HALL

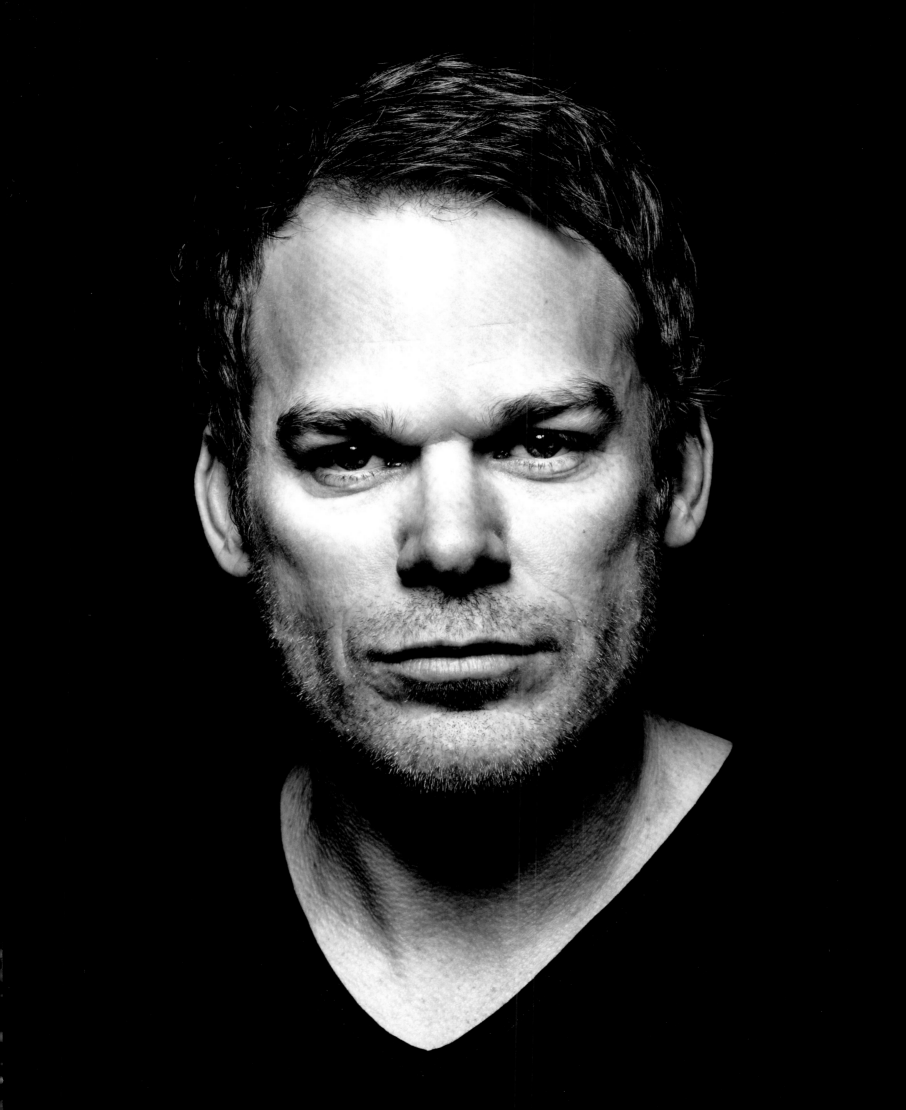

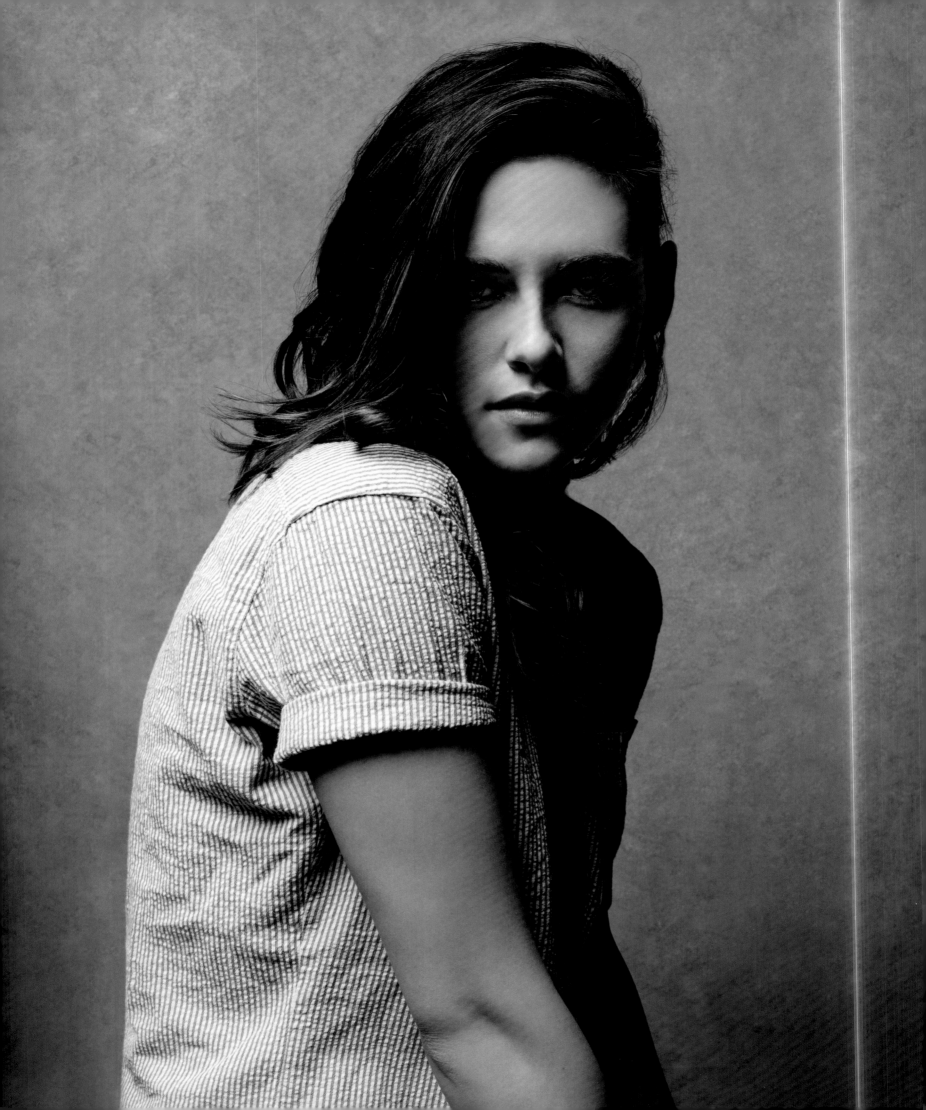

I always wanted to make movies like my parents,

both of whom were hardworking crew members. I wanted to come home with hundreds of stories and plates of food nicked from craft services, looking like I had just been through absolute hell. I thought what they did for a living was awesome. I still do. They were like pirates or in a traveling circus. I, though, was too small to be a grip like my brothers were, so, I figured I'd act. It was my only option. The problem was getting a job. I was eight years old, and wasn't very child actor-y.

After a year of failed auditions, which culminated in an emotional afternoon meeting for the film *The Safety of Objects*, I thought, "Wow this isn't just a cool job like my parents have, this is who I am." That was the day my dream of being a grip or a script supervisor shattered, and my life opened up beyond my wildest imagination.

In my favorite novel, *To Kill A Mockingbird*, Atticus Finch says, "You never really understand a person until you consider things from his point of view...until you climb into his skin and walk around in it." It wasn't until I began acting that I discovered the true meaning of that statement. Acting makes me feel like I'm a part of something larger than myself—we're all connected.

JESSICA CHASTAIN

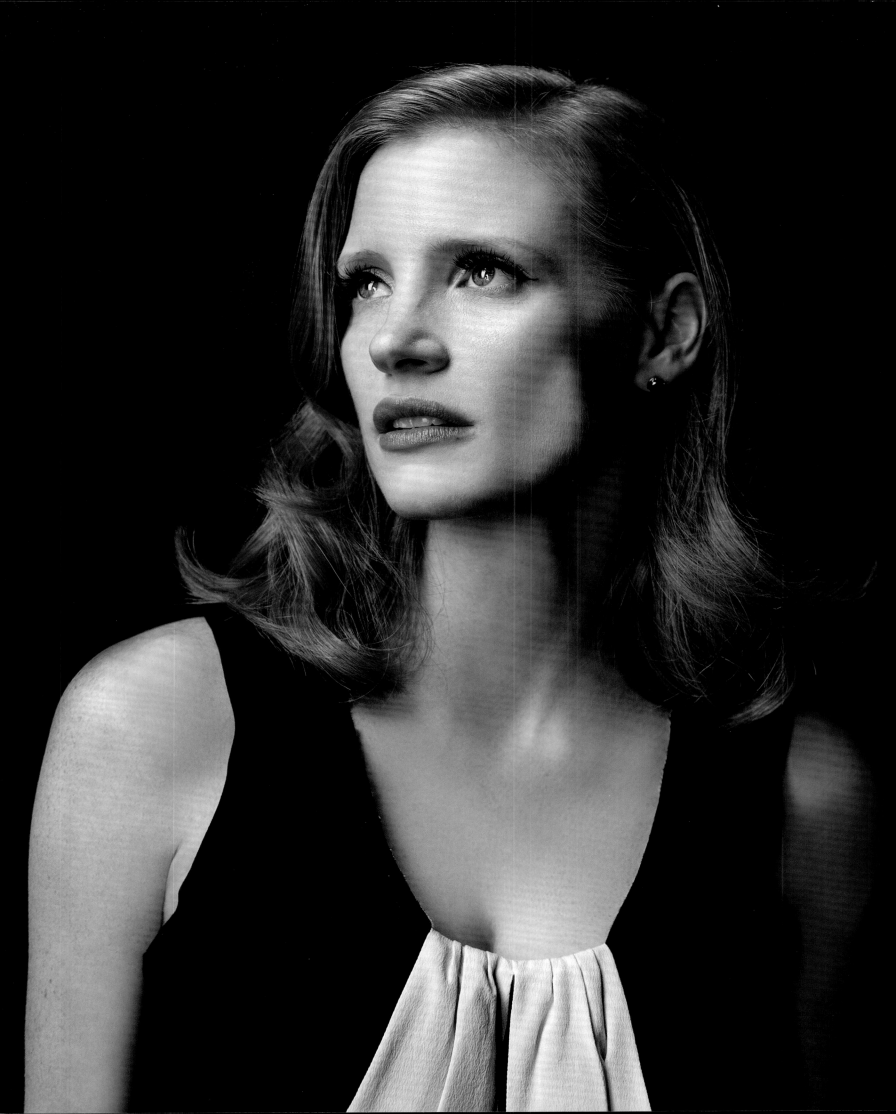

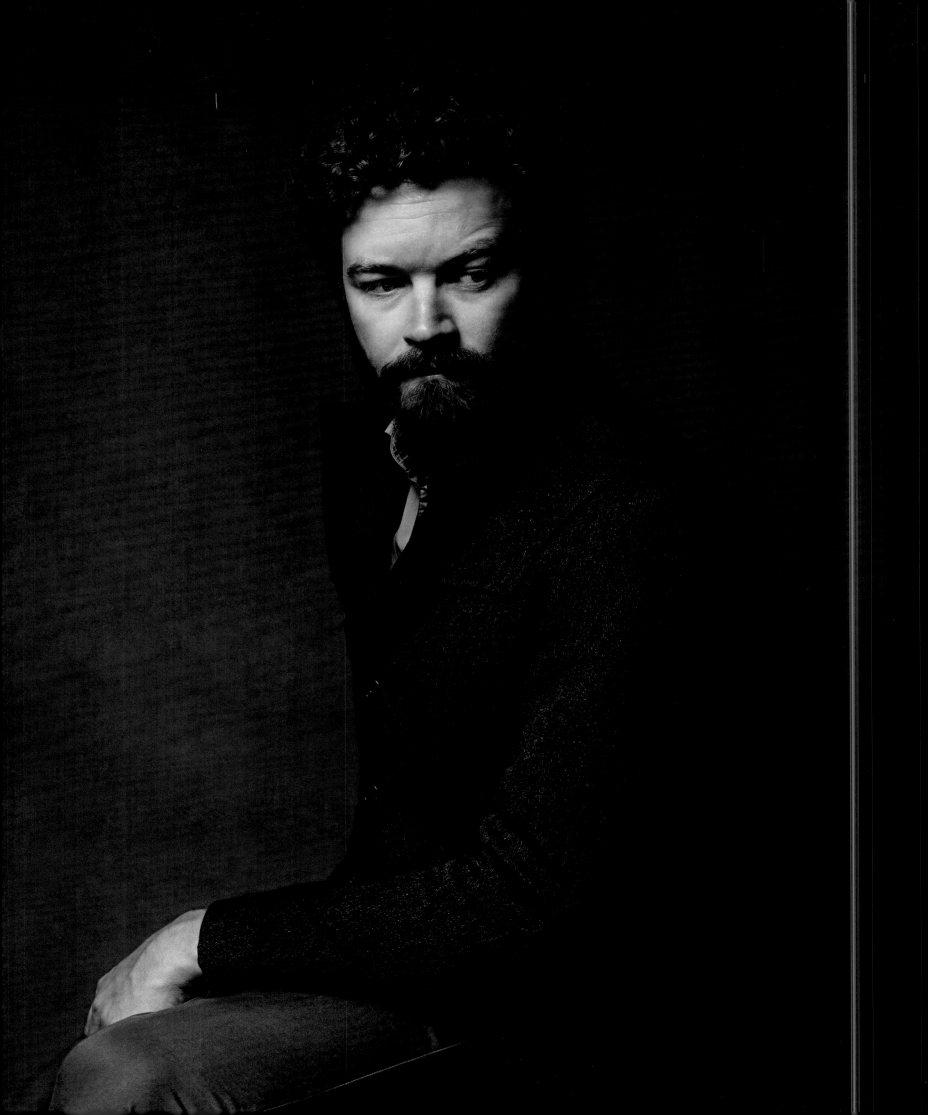

The First Time I

HEARD
PEARL JAM
WATCHED
SEAN PENN
READ
CHARLES BUKOWSKI
SAW A
BRYTEN GOSS
PAINTING

Changed Me
Forever

•

I saw **MICHAEL JACKSON** live
when I was 11 years old. My older cousin took me to the *Bad* concert. We had terrible
seats — so far away in a huge arena, I could barely see him and was forced to
watch him on the screens. When he walked out in his hat and glittery outfit and started
singing and dancing to *Bad*, I got goose bumps. I felt like he was performing
just for me. I knew then that I wanted to be someone who would make people
feel like I did that day. My life had a new purpose.

I GREW UP IN TALLAHASSEE. I LOVE THE SOUTH. I GO BACK a lot. Sports was a religion down there. Every church sermon was pretty much about football. The athletic, good ole boy ruled. And I wasn't that. I was a sensitive kid, quirky, kind of nerdy—a creative kid who was bullied in high school. In seventh grade, my parents said, "You know, we'll just sign Anthony up for the Young Actors Theater." It immediately clicked with me. It was a safe haven where I had permission to be creative and not be judged. Because typically, in the South, if you were in the arts, there was a lotta judgment.

The Young Actors Theater was run by Tina Williams. Tina represented an artistic, cultural world to me. Her favorite color was pink, and the theater was painted pink and black on the outside. I can still smell the theater, the smell of the fabric on the seats. I remember the relationships. I remember the freedom being around people who got me. It was freedom to just be who you are, where you are at, and not be judged.

Arts gave me the freedom to discover who I was.

In my debut, I played the Mayor of Munchkinland in *The Wizard of Oz*, complete with green topsiders. Tina's still there and when I got my Emmy, I called her.

CHILI
PEPPERS

During one of the first shows the PEPPERS ever played, we unleashed this
power that we didn't know that we had or knew existed. In this dark dingy
room, someone was swinging a beer bottle over his head, and the
erupting foamy beer formed a white halo. The image froze in my mind. I felt like
I was floating, and I was free from any pain or earthly constraints.

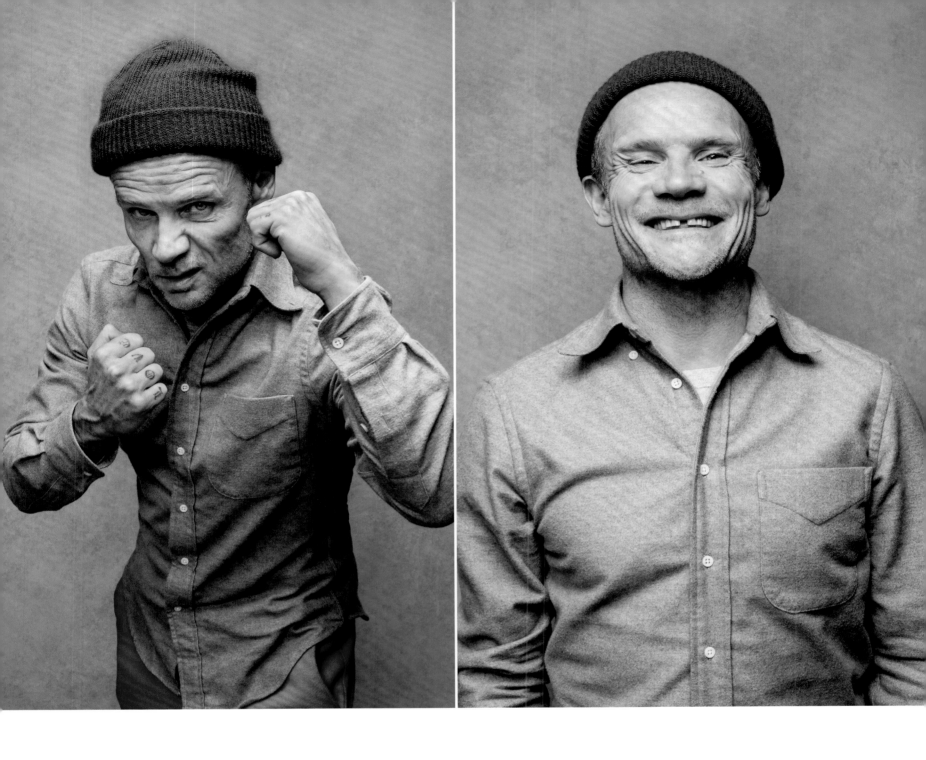

If you're a street kid, like me, and you didn't really have a functional
family at home, you searched for that sense of family and camaraderie elsewhere.
I found it by making music with other street kids. Ultimately, it became

A QUEST
FOR LOVE.

There was a little theater on the third floor
of Morton East High School in Cicero, Illinois. It was in that
theater, on a dare, that I tried out for the play *West Side Story* in
the fall of 1963. Until then, I had only seen two plays in my life.
The idea of becoming an actor was as far-fetched as if I
had decided to become a Martian. 50 years later, I remember it like
it was yesterday—walking up on that stage, looking into the
blackness beyond the footlights, singing my audition song into
that dark void, and hearing a smattering of applause coming from
the darkness. As if hit by a lightning bolt, I knew in that instant
that this is where I wanted to spend my life—on a stage somewhere,
somehow. Perhaps it was the combination of never having
had any recognition for anything I'd done before, plus the sheer
magic of being in this foreign place that, up to that night,
I didn't even know existed in our school. I haven't looked back since,
and it set the course for my life's pursuit. Incidentally, I didn't
get cast in that play, so the magic of that little theater was
enough to keep the fire burning well beyond that night. I've since
visited my old school. The little theater is gone now,
but to me that place will always be

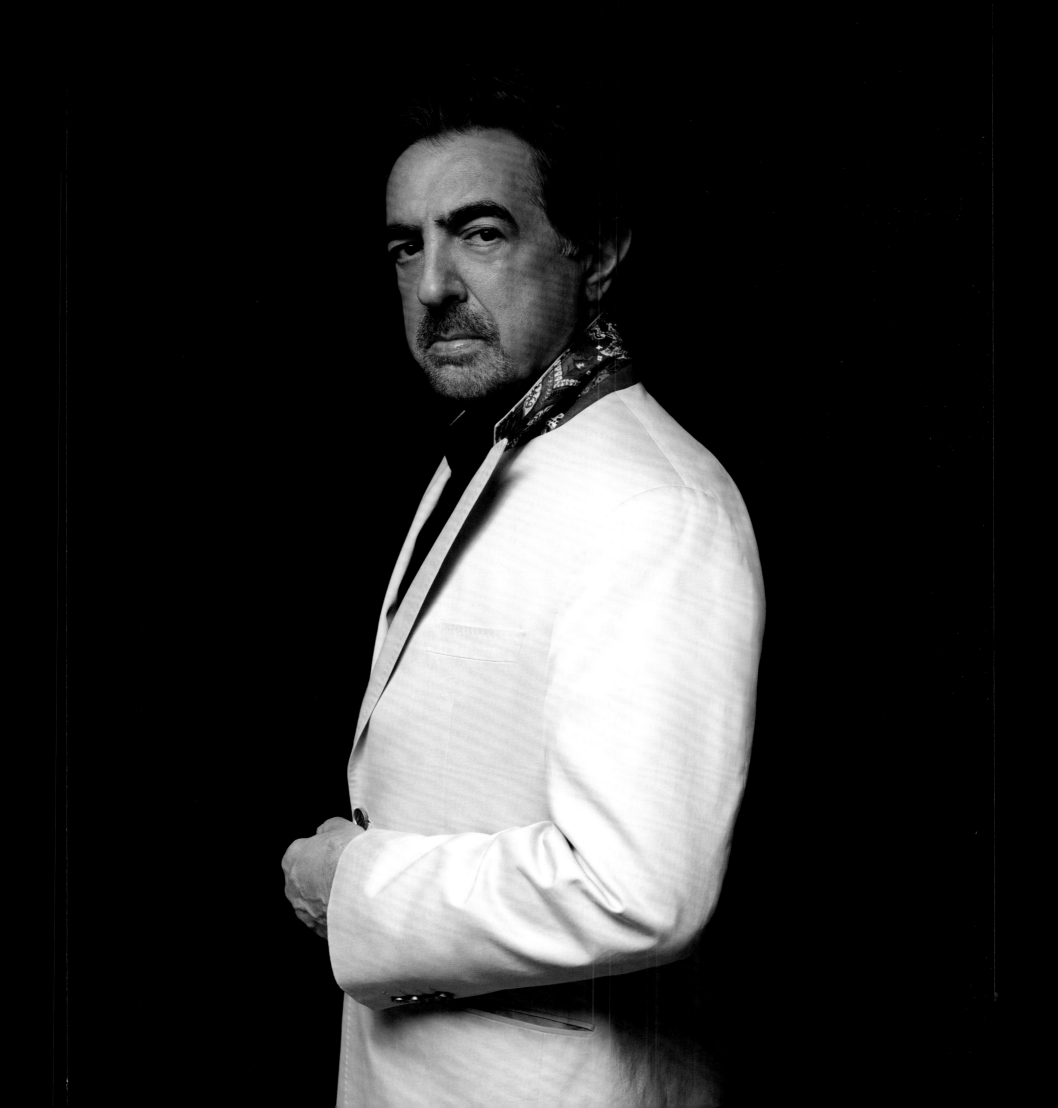

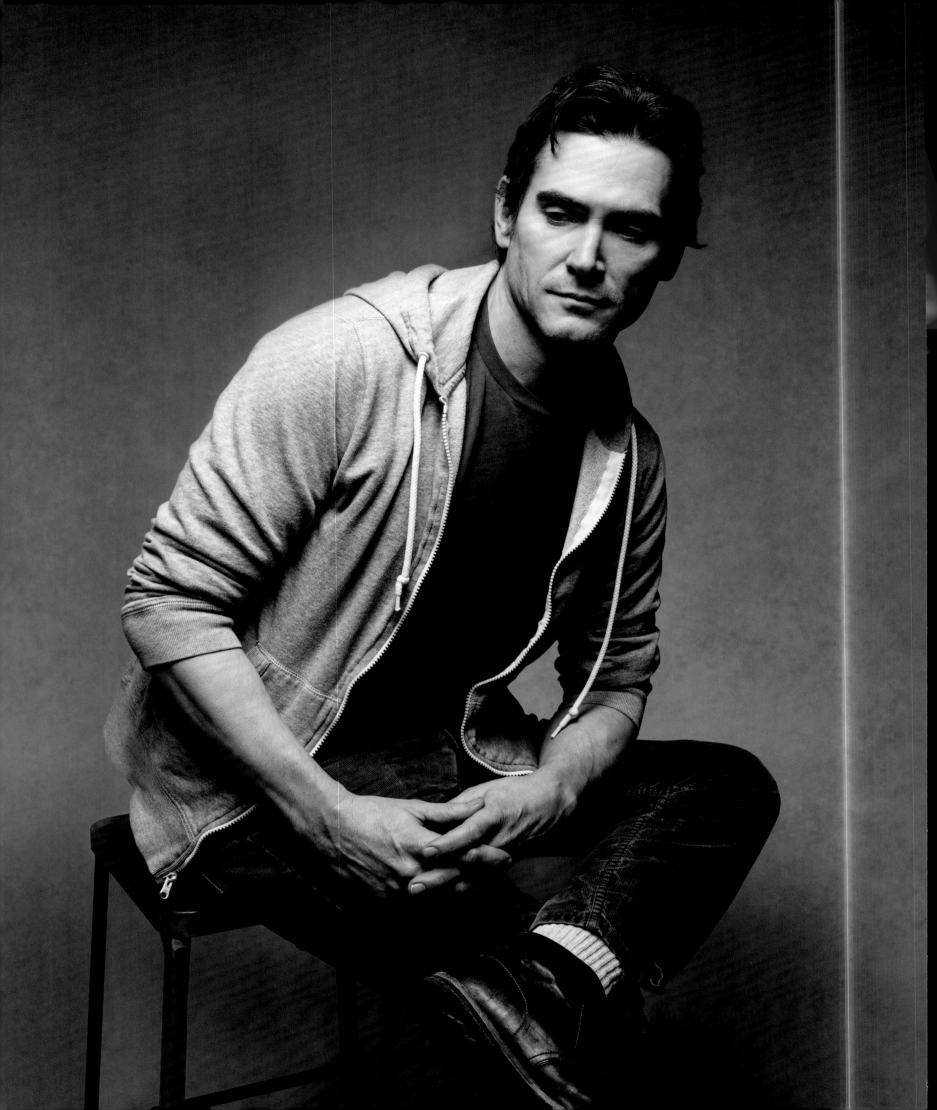

When I was 30, I was given a telescope
as a present. Shortly thereafter, I found myself in
New Mexico, and pointed it at the brightest
object I could see in the night sky.
It happened to be Saturn. When one sees the rings
of Saturn, vividly, with your own eyes,
the universe becomes a more exciting place.
I had spent much of my 20s so sure
that I had all the answers for almost everything.
In the blink of an eye, I was ten years
old again, and

THE WORLD WAS FULL OF WONDER.

I was sitting on a wooden bench in a black-and-yellow
striped carnival tent located at the end of a rather depressing midway.
I was waiting for Dr. Hypno to perform his

My seven-year-old brain wondered, "What could this show really be?
Could the good doctor actually make a gorilla materialize before my very eyes?
Or was this just another cheap carnival trick for suckers only?"
The lights dimmed to a low gloom. Crackling calliope music blared forth from
the sound system. Dr. Hypno and his willing female victim, dressed
in a tiny leopard-print bikini, stepped out. "Why is she doing this? Is she under
his spell?" Then into the cage she goes. The lights flash like lightning.
For a brief moment, through the murk of the cage, I see her body slowly
transform into a skeleton and back again. Another flash! Suddenly, a wild gorilla
is standing a mere 20 feet from where I sit! How could this be? I was no rube.
I knew the P.T. Barnum scams of the midway, but at that moment,
I was thrilled and horrified. The man in the cheap gorilla suit was all too
real, and I understood in that moment, for the first time,
the power of show business.

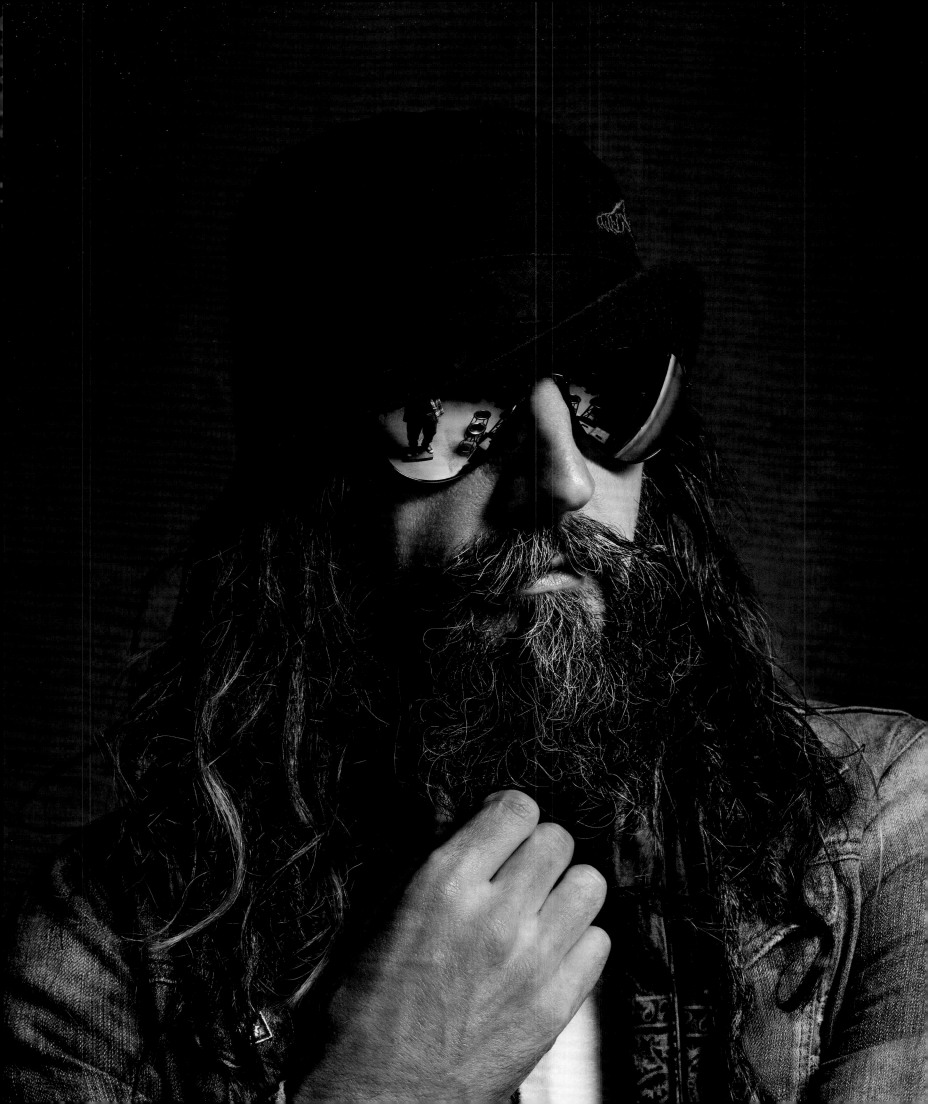

When I was ten, my father passed away. We had absolutely
no money. My father left the family with four hundred
dollars in the bank. I loved horses and I was determined
to ride, so I walked dogs to raise money to buy riding
lessons for myself. I was invited to take part in a horse show.
Now in order to be in the horse show, I needed riding
boots, breeches, and a white shirt. I didn't have any of
those things, and I knew that all of those things cost money.
One of my dog-walking customers offered me the most
beautiful breeches and shirt that I'd ever seen—so beautiful
and in pristine condition. I was thrilled and so grateful.
The day of the horse show came, and immediately
my mother and I noticed that every single girl had a jacket.
My mother started crying because I didn't. I got my horse
and waited in the barn to go into the corral, and watched
the event before mine. There was a girl named Laura
who was an amazing rider—so fluid on her horse, and
so connected to it. She won her event and, as I was waiting,
she walked by me and offered me her jacket. It fit perfectly.
I got into the ring and I became Laura. I won first place.
It was the transformative power of the imagination
coupled with the power of kindness. I have that trophy in
my office, I look at it every day, and remind myself that

THE MOST IMPORTANT THING IS MY
IMAGINATION.

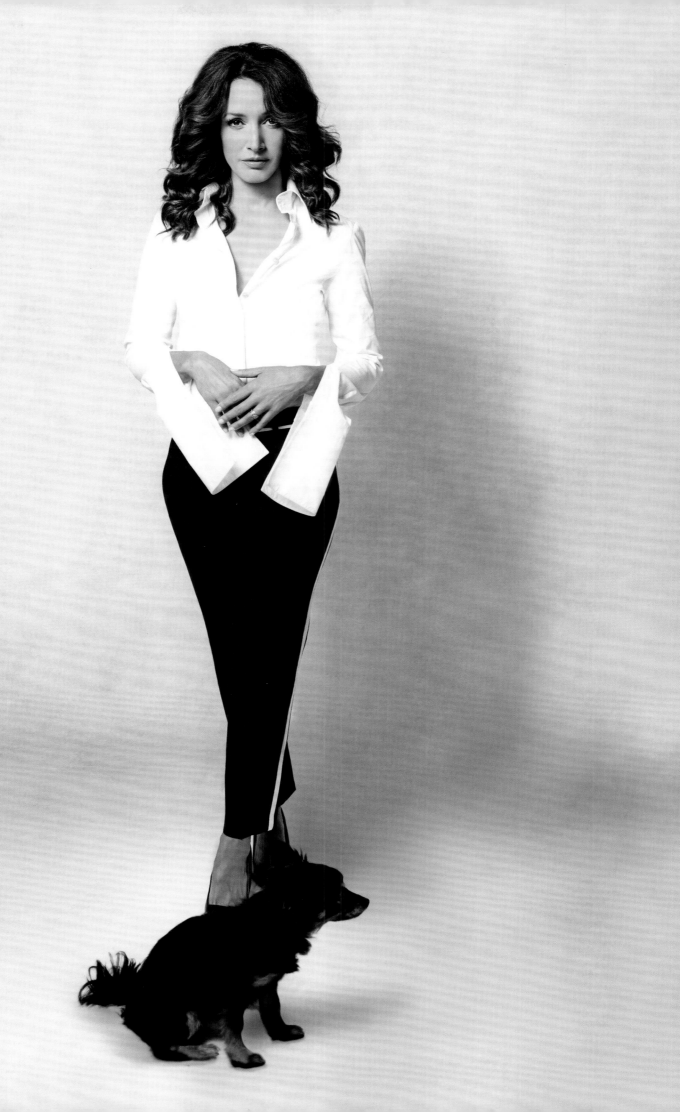

**As
a drama
student in
London,
you can be
subjected to almost
crippling
stiff upper-lippery.**

When I was 21 and seeing as much
theater as my flimsy wallet would
allow, I had the joy of encountering
Jesus Hopped the 'A' Train by Stephen
Adly Guirgis at the Donmar Warehouse.
It was visceral and electric, pungent and potent.
Ron Cephas Jones showed me how powerful it can be
to leave self-awareness at the stage door.
It was a life-changing production.
It was directed by Phil Hoffman.
I worked with him years later, but
never had the courage to tell him
how much it meant to me.
Don't know why.
I'll always regret it.

CHRIS O'DOWD

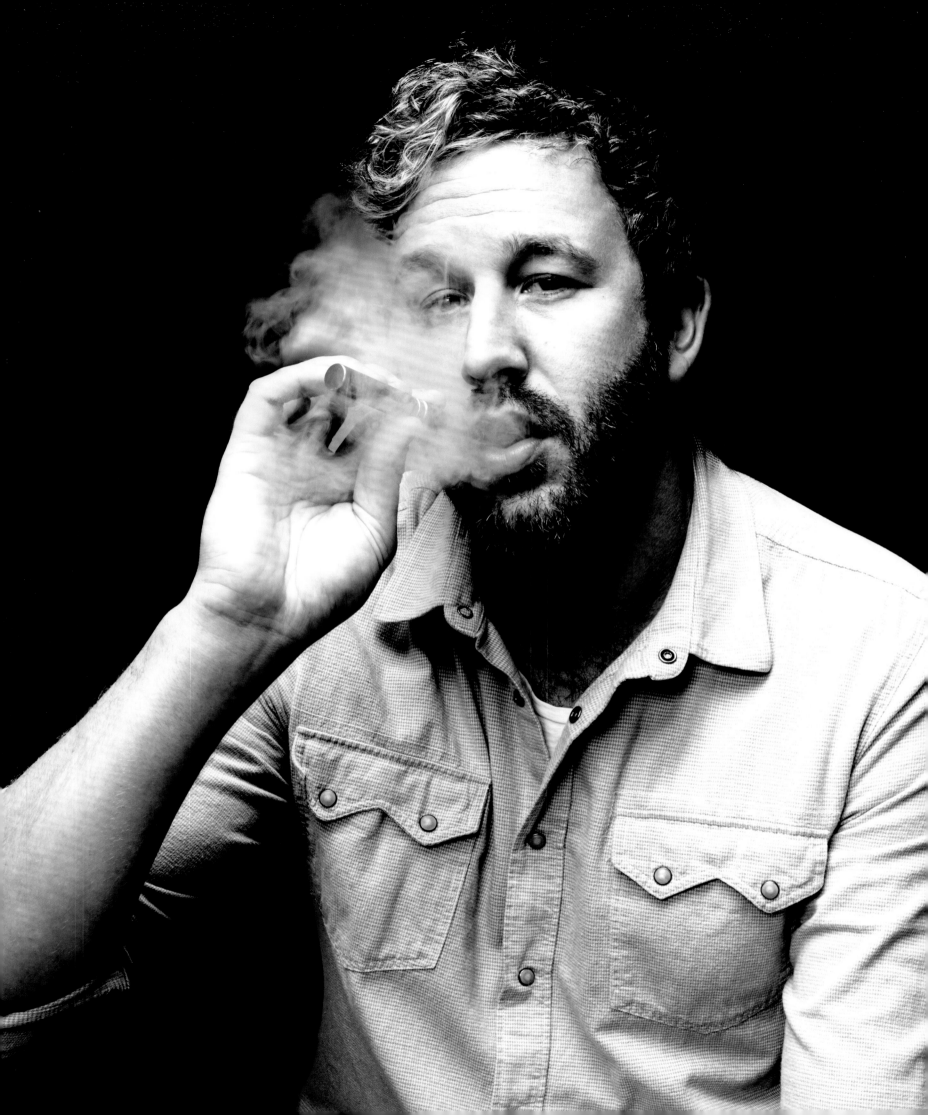

I WAS 11 YEARS OLD AND PART OF
A GROUP OF KIDS WHO SANG.
WE REHEARSED A LOT AND PERFORMED
IN WEEKLY SHOWS AROUND TOWN.
I GUESS YOU COULD CALL US A
PROFESSIONAL BUNCH OF AMATEURS.
ONE TIME, INSTEAD OF JUST
SINGING TO THE WHOLE AUDIENCE,
I CHOSE INDIVIDUALS AND
LOOKED AT THEM, RIGHT IN THEIR

IT WAS SO INTIMATE.
IT'S HARD ENOUGH TO LOOK ANYBODY
IN THE EYE, LET ALONE SING
TO THEM. AFTER THE SHOW, EACH
PERSON WHO I SANG TO CAME UP
TO ME AND TOLD ME HOW AFFECTED
THEY WERE BY MY SINGING.
IT WAS A POWERFUL, AMAZING,
ELECTRIFYING EXPERIENCE FOR THEM.
AND FOR ME.

ERIKA CHRISTENSEN

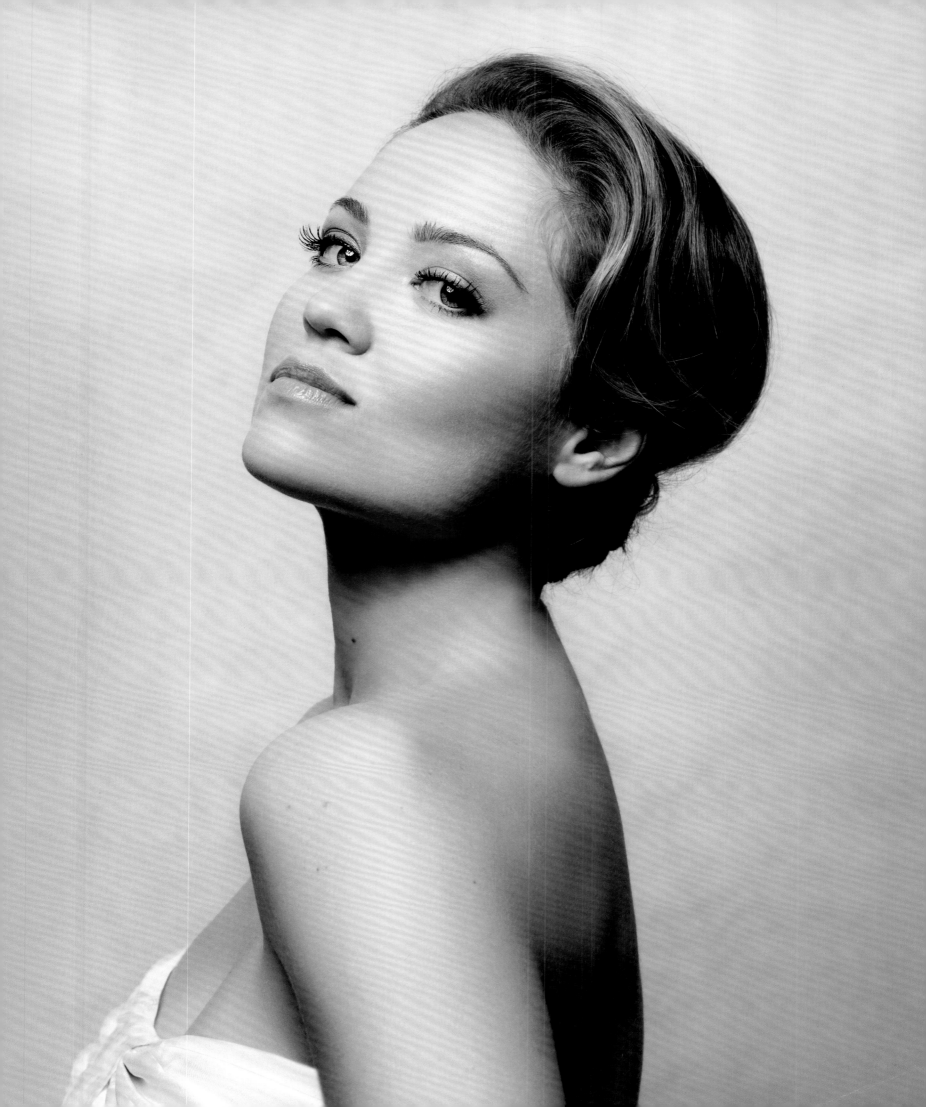

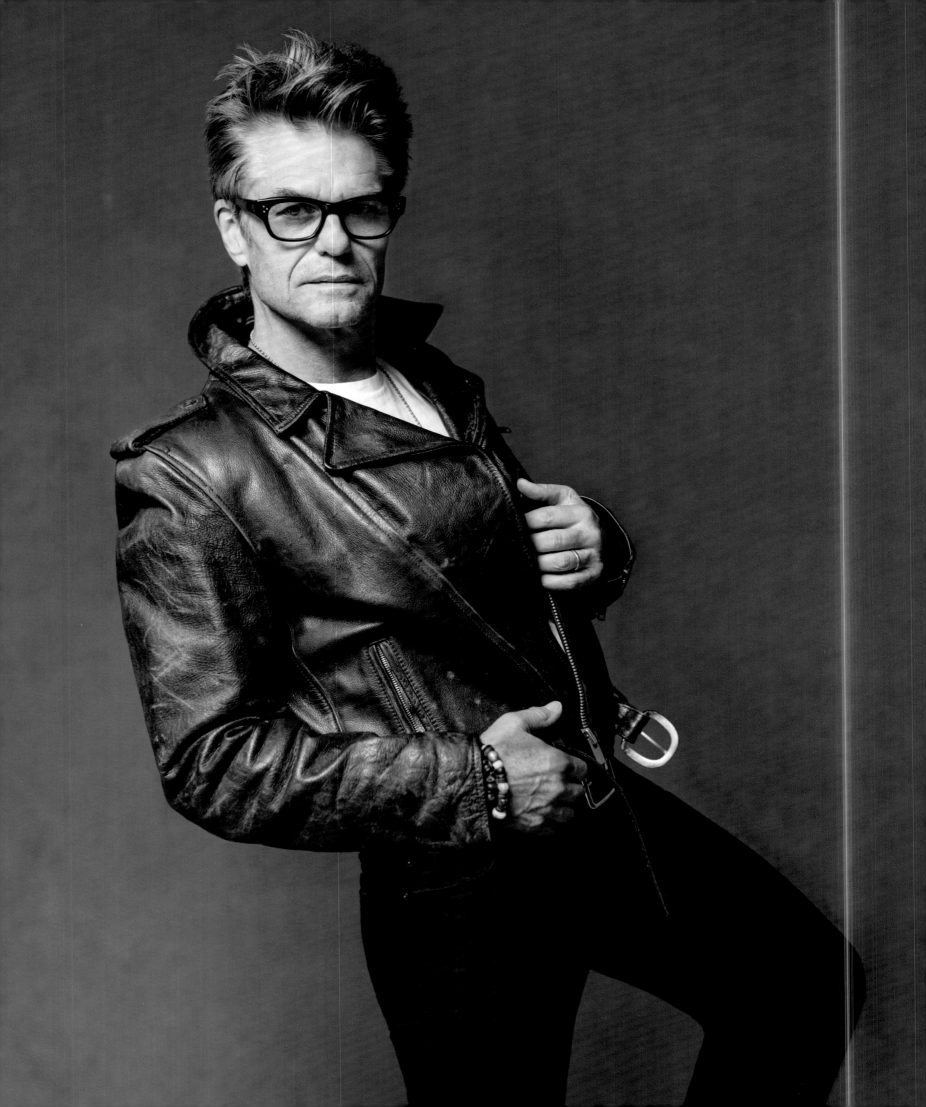

Early in the summer of 1964, my mother took me from Pasadena, California, to New York City on a two-week expedition that was intended to introduce this young 13-year-old to the finer things in life. The object was to teach me the secrets contained in volumes by Emily Post and Amy Vanderbilt, as well as to expose me to the Metropolitan Museum of Art, the Museum of Natural History, and the wonders of live theater on Broadway. We stayed at the St. Regis Hotel, hired horse-drawn coaches in the park, and dined on caviar and toast points at the Russian Tea Room. I was tasked with flagging down cabs, calculating tips, and opening innumerable doors for my diabolical, mink-clad mother. It was the single worst experience of my young life, and poisoned my relationship with my mother until the day of her death in 1992. There was one reprieve, however, one experience sandwiched in between the horrors of that trip that changed my life forever and set me on the course that I have traversed for the last 50 years.

"Serendipity!" my mother would say as I screamed that I hated theater and tried everything to get out of a midweek performance of *Hamlet* on Broadway. The very last thing a hormone-charged 13-year-old would want to do was to sit around a bunch of old people watching an unintelligible Elizabethan play by a long-dead English guy named Shakespeare. "Serendipity?" I didn't know what it meant, but that was the word I kept hearing coming out of my mother's pursed crimson lips as she forced me to put on a coat and tie and spit shine my shoes. She dragged me to the Lunt-Fontanne Theatre, where Richard Burton, clad in plain black rehearsal clothes, performed *Hamlet* eight times a week. The theater was packed to the rafters and we had good seats in the center. Though the stage was bare, the lighting created the space, and the mood was set for Shakespeare's greatest tragedy. I had neither read the play, nor did I have any idea what I was about to see. As the play began, I struggled to understand the verse and follow the plot. I could tell that Burton was good, and it was evident that the subject was very, very serious. There were ghosts and soldiers and kings and queens and a good deal of shouting. At some point, Burton stabbed someone through some clothes on a rack. It was clear that he had killed an old man. The theater was rapt and silent with all eyes and ears focused to the stage. As some players were running about trying to locate the murdered man, the King demanded of Hamlet, "Where is Polonius?" (the murdered fellow). Burton put his finger to his nostril and said, "But indeed, if you find him not within this month, you shall nose him as you go up the stairs into the lobby."

The entire audience broke into uproarious laughter. I got the joke too, and practically peed my pants. I was deeply impressed that, in the midst of a serious tragedy, Burton was able to crack an outrageous joke that set everyone into convulsions. I remember thinking, at that very moment, that I was seeing genius. I now know that was the moment I found my calling. The hook was set, but I was not pulled out of the water and on the deck until we went around to the stage door after the play to catch a glimpse of the handsome star leaving the theater. A small crowd had gathered around a black stretch limousine parked next to the stage door. The windows were tinted, so nobody could see inside. We waited and wondered when he would emerge, and if anyone would be with him. The stage door finally swung open and Burton, clad in jeans, a camel-hair coat, and scarf, swept into the car. The car door opened and we saw, engulfed in a sea of red roses, Elizabeth Taylor, waiting for her man. Burton slid in beside her. As flashbulbs exploded like Fourth of July fireworks, they kissed and were swallowed by the roses. The car door closed. The limo drove off, and my fate was set. I had to have a moment like that in my life. I'd say I've been pretty lucky because…I have, and then some! Thanks, Mom!

I FOUND A LETTER

I had written to myself when I was 17. I wrote about how difficult it was for me to understand how my family didn't support something that I was so passionate about, something I loved so much, something that made me feel so alive. I didn't understand why my family abandoned me when I found something that made me feel so alive. My family had told me that I could do anything in my life if I put my mind to it. How come I could be an astronaut, lawyer, scientist or doctor but I couldn't be an actor? It's in my blood. I'm a fourth-generation entertainer. I fell in love with the craft because, for the first time in my young life, I actually felt like I mattered—to be able to affect people by channeling one's demons; to get them to love you or hate you or laugh at you or laugh with you. I knew when I was acting I was touching hearts and it was then that I knew that I mattered, and I had purpose.

*It is things quiet and
commonplace that creatively
inspire me:*

*A gesture of someone
sitting across from me on a
subway train.*

**The strange way a young
man picks his tomatoes out of his
salad while telling a story.**

*The slight clash of certain regional accents
in someone's speech because they grew up in
two different parts of the country.*

*The singular and surprising way one man
holds his hands when he walks.*

**It is in the unimaginable
and unlikely, subtle things, where
I seem to get the biggest kick.**

*I am not sure why, really. I have stopped
looking too hard for profundity, because that never
really leads me anywhere profound.*

My two older brothers and I
were raised in Texas.

BEING AN ACTOR WASN'T IN THE VERNACULAR OF MY DREAMS.

I never dreamed about it because it wasn't something that I could even envision. I only saw two movies before I was 17, *Orca* and *King Kong*. The plan always was: go to school, go to college, get a job, and work your way up the ladder. It was a practical approach to making a living. We never talked about art or had art in the house. I went to the University of Texas, and was headed toward law school, but at the end of my sophomore year, I became increasingly uncomfortable with the idea of graduating, going to law school, and basically not being able to make an imprint on society until my early thirties. A friend who was going to NYU Film School said, "You know what, Matthew? You're a great storyteller. I don't know if it's behind the camera or in front of the camera, but I think you have a future in this. I love what I'm doing at NYU and you should check it out, too." His advice, and reading the book *The Greatest Salesman in the World* gave me the courage to call my dad and say, "I'd like to go to"—and I had to clear my throat—"film school." After a long pause, my dad said, "Is that what you really want to do?" And, I said, "Yes, sir." And he said, "Well then, don't half-ass it, son."

WHEN I WAS WORKING WITH MARTIN SCORSESE
for the first time in *After Hours*, there was this moment of
it all coming together—the camera work, the people,
the director. Scorsese really trusts his actors. He leaves a lot
of room for improvisation, which is my favorite thing to do.
We had been up all night, we were tired, and just
started having fun. During the dinner scene, he asked me,
"Do you think she'd laugh here?" He simply said
those words, and this weird laughter bubbled out of me.
My whole basic training in life is

For all of the Arquettes, really.

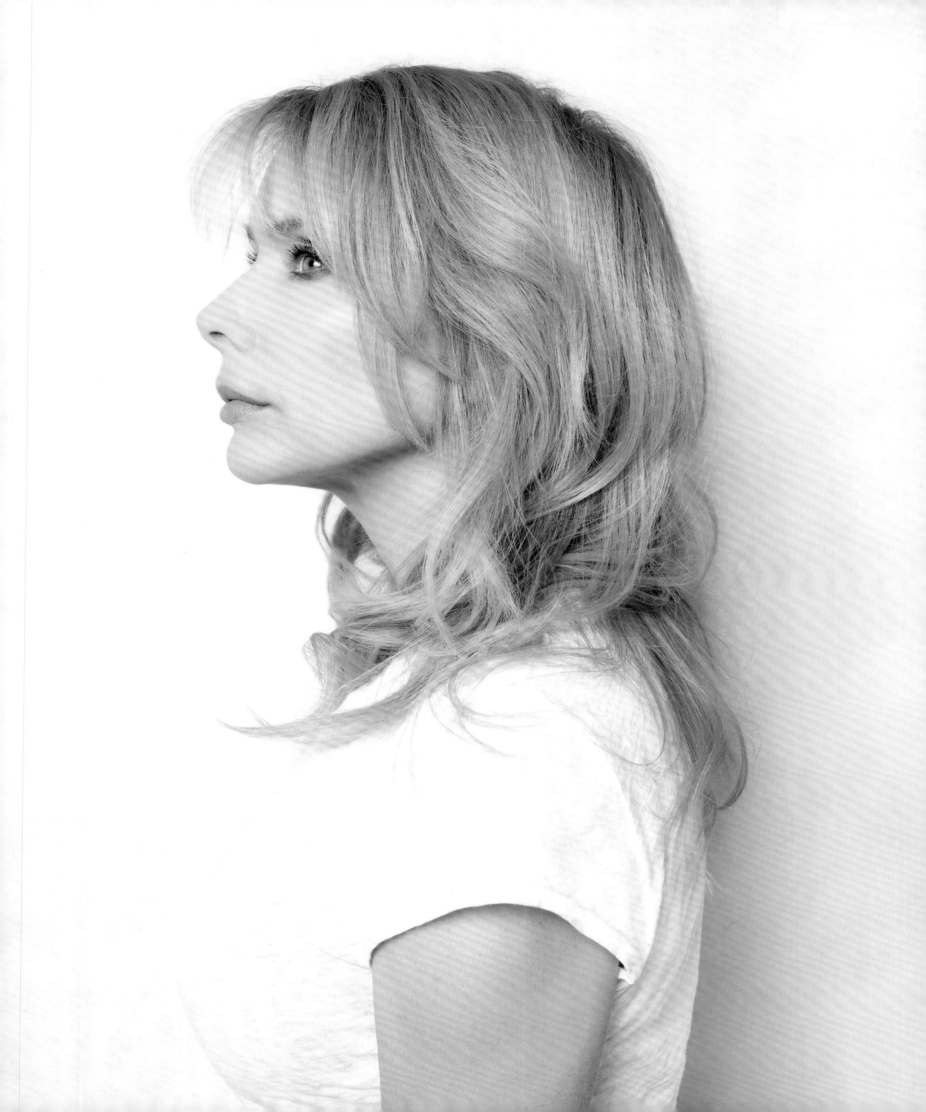

We grew up near Melrose Avenue and Gower Street in Hollywood, right down
the street from Paramount Studios. When I was ten years old, I would walk there alone, stand
in line, and watch all the shows filmed in front of a live studio audience — *Happy Days*,
Laverne and Shirley, Mork and Mindy. I was completely obsessed. I watched the tapings all day,
and then I'd stay to try and meet the casts after. One time, Henry Winkler came out and
shook everybody's hand. He was such a kind and gracious guy, just the coolest dude. I was a huge
fan and never forgot that. Many years later, I told him that story while we were shooting a
scene together for *Scream*. Henry said, "I'd like to shake your hand again." It's people like him who
rise above by understanding that it's always about the fan, about kids and their dreams
and making their dreams come true. This business is so crazy — it's an honor to be able to do it
for a living. It's also really tough because you have to achieve a balance between having
an incredibly strong ego and self-confidence and being humble and gracious. My whole thing
is trying to stay real, maintaining a relationship with fans and with people, in general.
Hollywood is a town that is built on fakery, as well as art.

My favorite art comes from honesty.

Honesty scares me a little, though. I was in a meeting just the
other day when someone asked, "Are you aware that people think you're crazy?"
Yeah, I'm pretty aware.

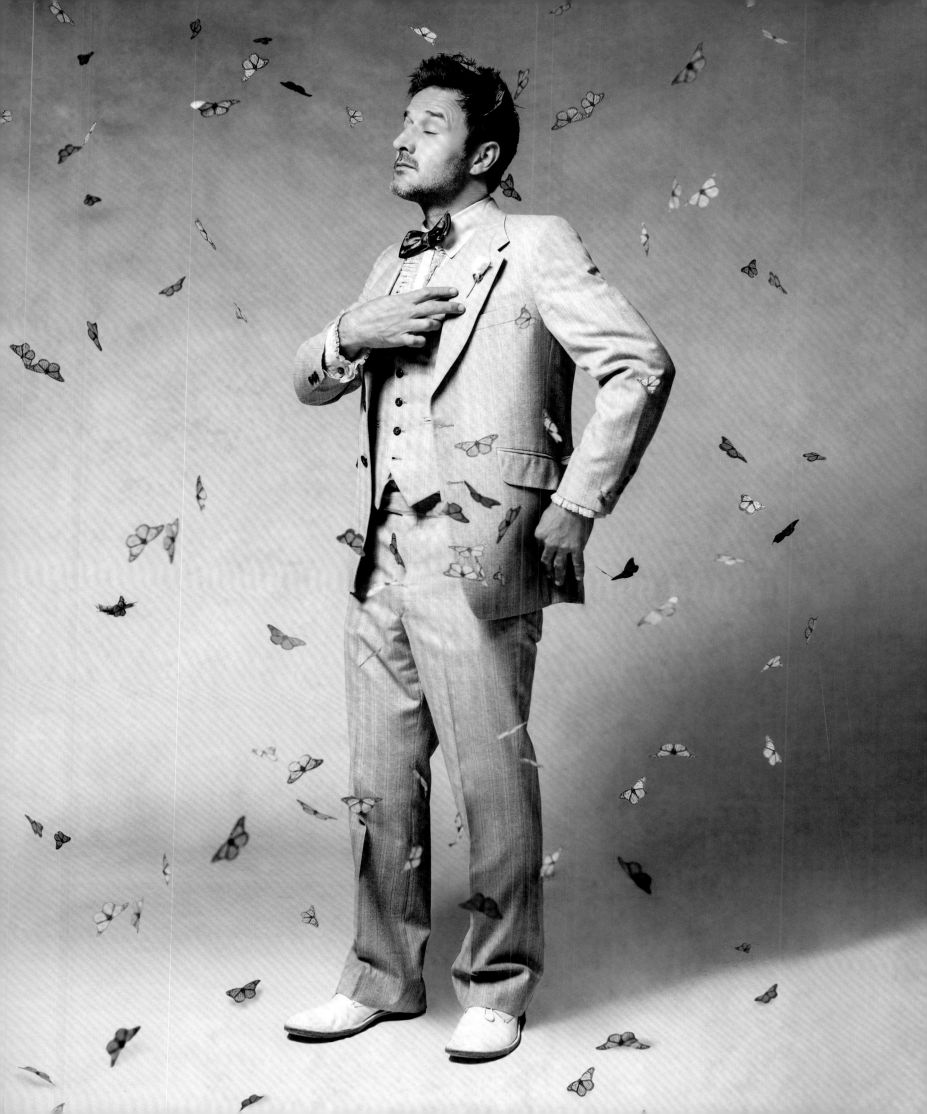

JEFF VESPA is one of the co-founders of WireImage, the largest entertainment photo agency in the world. He is also the CEO and Founder of *Verge,* a digital magazine which focuses on new and emerging talent. His photography has been featured in numerous publications including *Vanity Fair*, *The New York Times*, *Vogue*, T*he Wall Street Journal*, *Elle*, *InStyle,* and *People* magazine. He was previously the Editor-at-Large for *LIFE* Magazine's LIFE. com for three years and the West Coast Special Projects Editor of *Los Angeles Confidential* magazine for seven years. Recently he produced the documentary *$ellebrity,* which focuses on the history of publicity, gossip, and paparazzi in Hollywood.

ROBIN BRONK is an author and CEO of The Creative Coalition. She is a frequent writer and speaker on the role of entertainment in advocacy and has been featured in *The New York Times*, *The Wall Street Journal*, *International Herald Tribune*, *Los Angeles Times*, *People*, *The Boston Globe*, *The Washington Post*, and is a guest commentator on CNN, MSNBC, CNBC, NPR, PBS, Fox and other broadcast outlets. Ms. Bronk is a contributor to *The Huffington Post*, has edited two other books, *Art & Soul* and *If You Had Five Minutes with the President*, and pens a weekly "Five Minutes..." column for *The Hill* newspaper.

NANCY ROUEMY is the principal at We Live Type Ltd, a design firm in New York specializing in custom typography, branding and book design. Previously, she served as an art director at *The New York Times Magazine*, winning over one hundred awards, including the Pennsylvania State University 2014 Arts & Architecture Alumni Award for Graphic Design; both Gold and Silver medals from The Art Directors Club, Society of Publication Designers and Best of News Design. Rouemy's design work and approach have been featured in best-selling books and publications in the U.S. and abroad. She has been a Speaker at the Type Directors Club, AIGA San Diego Design Conference, The School of Visual Arts, Parsons The New School for Design, and New York advertising agencies.

CREDITS: Mike Windle, Photo Editor; Barb Horvath, Copy Associate; Jessica Shoer, Copy Assistant; Dane Christensen, Kevin Bryan, Kris Park, Photo Assistant; Annie Rose McGrath, Assistant

MAKEUP: Kindra Mann; Matthew Vanleeuwen; Toby Fleischman; Mai Quynh; Jeffrey Paul; Kelsey Deenihan; Jessica Ortiz; Christy Coleman; Kaley Mcadams; Fiona Stiles; Tsipporah; Ermahn Ospina; Coleen Campbell; Denise Dellavalle; Spencer Barnes; Lottie; Vera Steimber; Melissa Sandoval; Sarah Uslan

HAIR: Anh Co Tran; Ian James; Tony Chavez; Jonathan Hanousek; Josué Perez; Davey Newkirk; Jen Atkin; Alex Polillo; David Stanwell; Creighton Bowman; Tara Smith; Romy Fleming; Cyndra Dunn; Aviva Perea; Bobby Elliot; Nicole Walpert; Caile Noble

GROOMING: Gina Ribisi; Sydney Zibrak; Erica Sauer; KC Fee; Kim Verbeck; Helen Robertson; Bethany Brune; Thea Istenes; Kristene Bernard

STYLISTS: Avo Yermagyan; Petra Flannery; Elizabeth Stewart; Samantha McMillen; Ilaria Urbanati; Brad Goreski; Johnny Wujek; Karla Welch; Marissa Peden

AGENCIES: The Wall Group: Kate Stirling; Clarke Leisy; Kit Lejarraga; Dana Gardner; Melissa Moscovitch; Melissa Pursel; Tracey Mattingly Agency: Tracey Mattingly; Benoit Demouy; Brandi Benson; Exclusive Artists Management: Darin Barnes; Andy Marun

COLOR PROOFS: Proof Imaging: Kevin Kornemann and Ivan Huang

WITH SPECIAL THANKS TO

Kathleen Matthews; Catherine Leitner; Renaissance Hotels; Rizzoli; Charles Miers; Robb Pearlman; Daniel Melamud; Mark Sobel, Andrea Collins and Robin Baum Anomaly; APCO Worldwide; Current; Chris Allen; Madeleine Ali; Jennifer Allen; Chantal Alleyne; Jacqueline Anto; Dominique Appel; Craig Banky; Michelle Benson; Ruth Bernstein; Jeffrey Best; Amy Birnbaum; Gary Blake; Devon Bratton; Gerri and Burt Bronk; Larry Busacca; Mara Buxbaum; Wanda Claudio; Neal Cohen; Marisol Colon; Harold Cook; Jennifer Cranston; Tim Daly; Taylor Digilo; Trieste Kelly Dunn; Nelson Fernandez; Frankfurt, Kurnit, Klein & Selz; KFPR; Michael Frankfurt; Kari Feinstein; Dan Fox; Lindsay Galin; Julia Garner; GBK Productions; Stuart Gelwarg; Amy Gersten; Kenny Goodman; Carrie Gordon; Erica Gray; Lucy Gross; Hilary Hansen; Mia Hanson; Leah Harris; Leroy Harris; Marlene Harris; Jodi Hassan; Bella Heathcote; Lori Heden; Steven Heller; James Patrick Herman; Jackie Hook; James Hook; Jessica Hook; John Hook; Renee Hyde; Kimberly Jaime; Kate James; Brittany Kahan; Gavin Keilly; Colleen Kelly; Jeanne Kispert; Jessica Kolstad; Geyer Kosinski; Margery Kraus; Rachel Krivis; Lisa Kulak; Matt Labov; Susan Lee; Melanie Lemnios, Jennifer Libo; Heidi Lopata; Nick Maduros; David Manning; Gary Mantoosh; Shea Martin; Kevin Mazur; Marriott; Carri McClure; Simone McDermid; Mark Merriman; Roxanne Motamedi; Col Needham; Erin O'Neall; Jeremy Patashnik; Sue Patricola; Diana Pavlov; Nicole Perez-Krueger; Lisa Perkins; Kat Popiel; Alex Prager; Vanessa Prager; Tracy Reiss; Danielle Robinson; Ariel Rouemy; Isaac Rouemy; Israel Rouemy; Shirel Rouemy; Joshua Schmell; Annie Schmidt; Eric Seiff; Rachel Simon; Danica Smith; Johnny Sobel; Leah Sobel; Stephanie Sobel; Lanny Sommese; Abigail Spencer; Laurina Spencer; Dr. Adam Steinlauf; Brian Swardstrom; Chelsea Thomas; Edward Tricomi; Dan Vinh; Warren Tricomi Salons; Joel Warren; Meredith O'Sullivan Wasson; Danielle Weiss; Eliza Weiss; Kiki Weiss; Rachael Wesolowski; Joshua White; Bill Wolf; Veronique Vicari Barnes; Patricia Tuffs; Alan Wertheimer; Courtney Whelan and Max and Harry Vespa.

First published in the United States of America in 2014 by
Rizzoli International Publications, Inc.
300 Park Avenue South
New York, NY 10010
rizzoliusa.com

© 2014 The Creative Coalition

Project Editors: Robb Pearlman and Daniel Melamud
Art Direction and Book Design: Nancy Rouemy, We Live Type Ltd

2014 2015 2016 2017 / 10 9 8 7 6 5 4 3 2 1

Printed in China

ISBN: 978-0-8478-4430-2

Library of Congress Control Number: 2014940508